.athor.
Dayton through time

DAYTON
THROUGH TIME

CURT DALTON

AMERICA
THROUGH TIME®
ADDING COLOR TO AMERICAN HISTORY

AMERICA THROUGH TIME is an imprint of Fonthill Media LLC

First published 2015

Copyright © Curt Dalton 2015

ISBN 978-1-63500-007-8

Typeset in Mrs Eaves XL Serif Narrow
Printed in the United States of America

Published by Arcadia Publishing by arrangement with Fonthill Media LLC

For all general information, please contact Arcadia Publishing:
Telephone 843-853-2070
Fax 843-853-0044
E-mail sales@arcadiapublishing.com
For customer service and orders:
Toll-Free 1-888-313-2665

Visit us on the internet at www.arcadiapublishing.com

INTRODUCTION

Dayton, Ohio endured many trials and tribulations during its early history. In 1795, Judge John Cleves Symmes, a land speculator from New Jersey, sold Arthur St. Clair, General James Wilkinson, Israel Ludlow and New Jersey Congressman Jonathan Dayton, land that became known as the "Dayton Purchase." When the village was laid out, it was agreed that it should be named after Congressman Dayton.

Unfortunately, Symmes later failed to meet his financial obligations to the federal government. It was also found that he never actually had the right to sell the land where settlers had built their cabins in Dayton, Ohio. When the US Government offered to sell the property to Ludlow, St. Clair, Wilkinson, and Dayton, they declined. In 1800, the government offered to sell the land to the residents, but at two dollars an acre, most of them could not afford to do so, as they had already given most of the money they had saved to purchase the land from Symmes. By the time the matter was settled in 1802, only five families resided in Dayton. Fortunately, one of the men was Daniel C. Cooper, who had both the means and the desire to save the town. In the end, he paid the government their asking price, buying over 3,000 acres of land, including the town site. The town was replatted and clear titles given to the few settlers that were left.

The War of 1812 helped bring prosperity to the area when Dayton was named as the rendezvous for the troops of Ohio and Kentucky. Three regiments of militia were organized here; the first encamped south of Dayton, and the second and third encamped in Cooper Park. Local merchants received high prices for their supplies, which helped the economy. After the war was over, some of the soldiers, impressed with the beauty of the city, decided to settle in the area. By 1820, Dayton's population had grown to 1,139.

Yet the city had one more hurdle to overcome. An economic depression hit Ohio, and Dayton in particular, after the war ended. The major problem was that the price of grain and meat was quite low, with wheat selling for ten cents a bushel and beef selling for a mere three cents a pound. Better prices could be obtained in the more lucrative Eastern markets, but there was no reliable means to transport the product there. In 1825, thirty river boats were held up by low water. That year a law was passed authorizing the construction of a canal between Dayton and Cincinnati.

The first canal boat arrived from Cincinnati to Dayton in 1829 and from that time on the city never looked back. It wasn't long before seventy canal boats a month were loading and unloading their cargo. In June 1829, Daytonian John Van Cleve wrote: "The streets are all busy, drays running, hammer and trowel sounding, canal boats blowing, stages flying—everyone doing something."

Dayton ranked first in the nation in terms of patents granted per capita as early as 1870. By the early 1910s, Dayton had become known as the "City of a Thousand Factories," manufacturing products that could be found across the globe, including cash registers, railroad cars, agricultural implements, computing scales and airplanes.

In 1913, Dayton suffered the worst flood in its history, with river water cresting at over twelve feet downtown. Yet, instead of giving up, its citizens raised two million dollars on their own and began the process of building five dams to protect the city from future flooding, a system that is still in use in 2015.

Although the economy slowed during the Great Depression and World War II, the 1950s saw the city expand and its total work force increase. However, the building of I-75 and US 35 in the 1960s had a major impact on the city, as thousands of residents moved to newly developed satellite communities. Suburban shopping centers opened, taking away the profits of downtown businesses. After peaking at more than 260,000 people in 1960, in 2010 the city has a population of less than 142,000.

Although the landscape of the city has changed due to urban renewal and highway construction, a number of the older commercial buildings, downtown residences, monuments and churches still remain. A number of examples of these gems can be found inside this book. Their comparative views are like a time machine into the past, giving you a glimpse of what the city was like long ago.

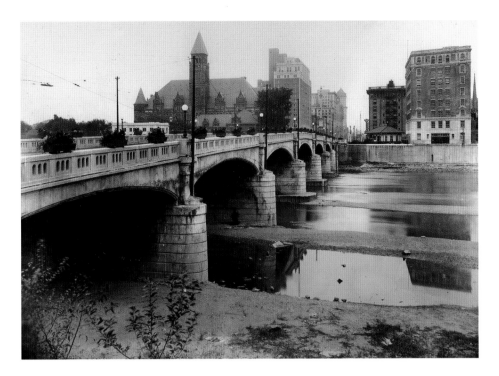

MAIN STREET BRIDGE INTO DAYTON: Shown here in 1931, the old concrete bridge would be replaced with a wider version in 1957. In 2014, although Steele High School is gone, many of the other downtown buildings can still be seen. On the left are the Biltmore Hotel, the Third National Bank and Trust Co. Building (now Paru Tower) and the UB Building. On the right is the 11 West Monument Building and the Insco Apartments Building. On the far right, the spire of Christ Episcopal Church can also be seen peeking above the surrounding buildings.

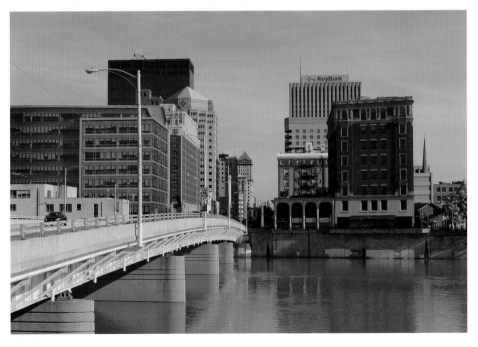

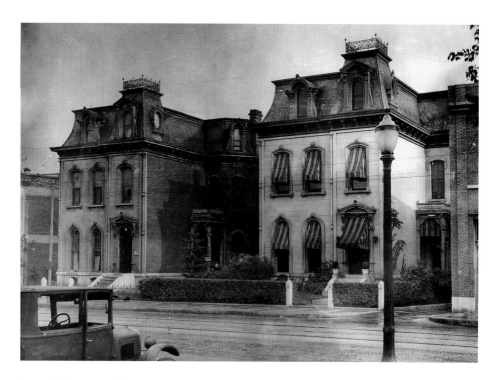

ISAAC POLLACK HOUSE: Built in 1876, this Victorian home originally sat at 319 West Third Street. In 1913, Fenton T. Bott purchased the building and opened a dance studio, which ran until 1941. From 1956 to 1976, it was used by the Board of Elections. The house was moved to the southwest corner of Monument Avenue and Wilkinson Street in 1979. It is now the Dayton International Peace Museum.

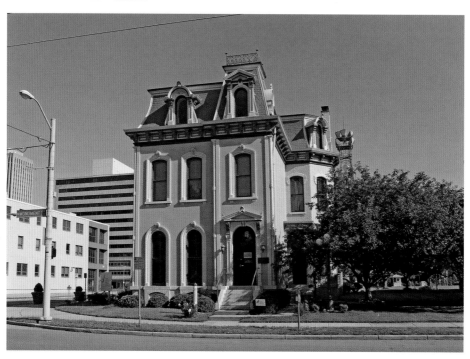

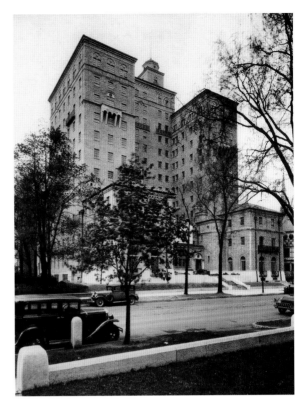

YMCA: Having outgrown three locations during its fifty-nine year history, the organization really expanded when it opened its new central branch at 117 West Monument Avenue in 1929. The thirteen-story building included 245 residence rooms for thirty men, three gymnasiums, a swimming pool, fifteen classrooms, an auditorium, a chapel and library, four handball/squash courts, an athletic club, and a cafeteria. Although still home to the YMCA, part of the building became an apartment complex in 1992.

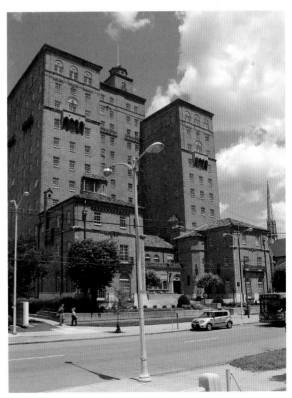

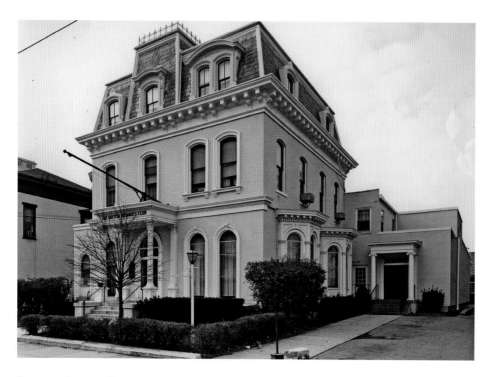

ROBERT STEELE RESIDENCE: Originally built in the 1840s as a Classic Revival home, this mansion at 225 North Ludlow Street was renovated in 1865 to more closely resemble the Second Empire architectural style popular during the reign of Napoleon III; which was fitting, as the owner during the renovation was named Napoleon Bonaparte Darst. In 1916, the home became the Dayton Woman's Club, which provides a wonderful setting for social events and programs for both its members and the public in 2014.

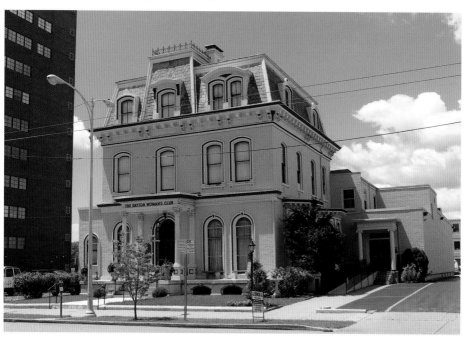

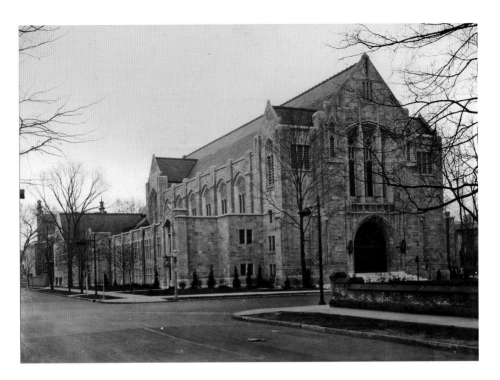

WESTMINSTER PRESBYTERIAN CHURCH: In 1919, the First Presbyterian and Third Street Presbyterian united into one congregation. They chose the name Westminster and dedicated their new church at the southwest corner of First and Wilkinson Streets in 1926. The Te Deum Window from the old First Presbyterian Church was reused in the Late Gothic Revival structure. Created by Tiffany Studios, this stained-glass art is a reminder of the Presbyterian's long history in Dayton.

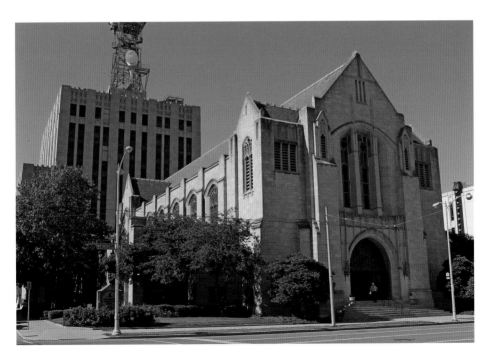

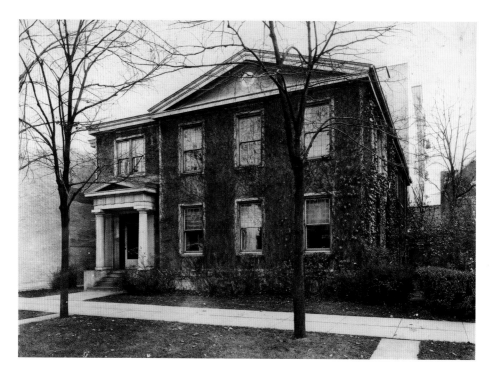

FOWLER-PARROTT HOUSE: This Greek Revival building is thought to have been built about 1834, making it one of the oldest structures still left in downtown Dayton. Once the residence of Henry Stoddard Fowler, it was later the home of his daughter, Elizabeth, who married Hamer W. Parrott. The building was remodeled when used by the BuzFuz Club from 1910 to 1930. The structure has since been converted into an office building.

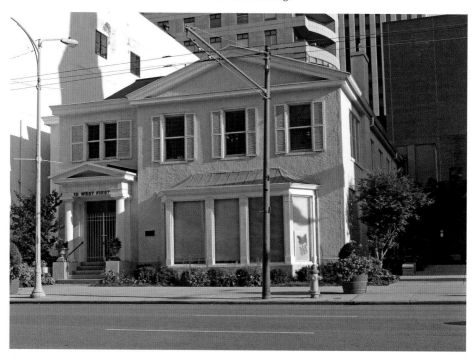

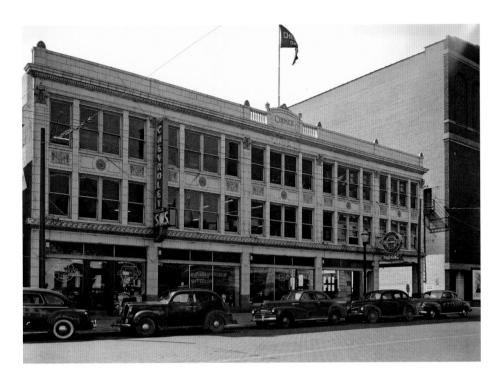

OHMER BUILDING: When furniture maker Michael Ohmer retired in 1878, his sons bought the business and the M. Ohmer Sons Company was formed. In 1888, they built a furniture factory at 24-32 East First Street. When they closed the factory to focus on the more lucrative Ohmer Fare Register Company, the building was converted into a parking garage. At the end of WWII, SWS Chevrolet took advantage of the new influx of automobiles being produced and opened a dealership there. It is once again a parking garage in 2014.

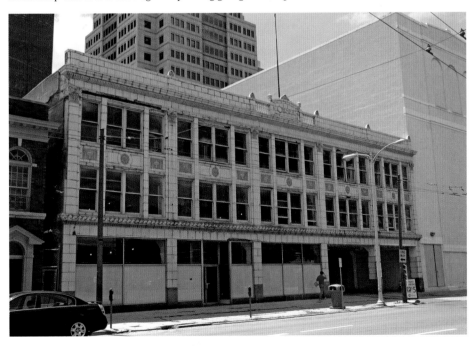

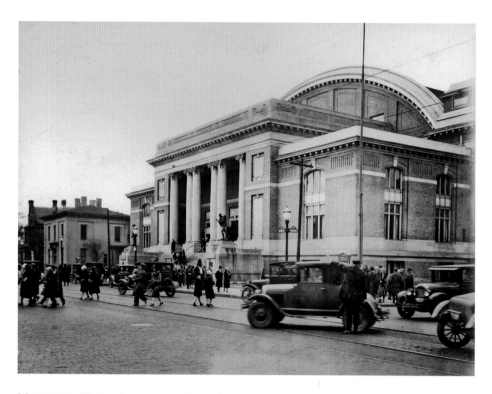

MEMORIAL HALL: Located at on the northwest corner of First and St. Clair Streets, the building is a monument to Montgomery County war veterans who served in the Civil and Spanish-American Wars. A parade, speeches and a fifteen-gun salute (one for each township) celebrated its dedication on January 5, 1910. In 2014, the property is used for educational and meeting venues.

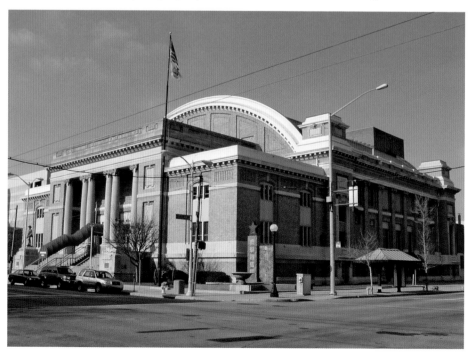

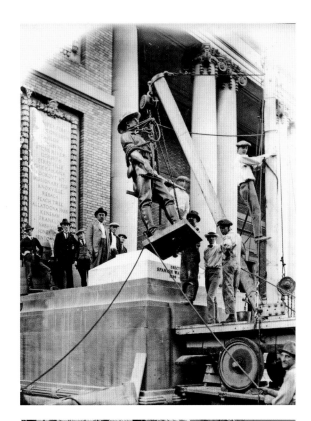

SPANISH-AMERICAN WAR MONUMENT: In 1923, two bronze statues, one depicting a soldier from the Spanish-American War and the other a soldier from World War I, were added on each side of the main entrance of Memorial Hall. The Spanish-American Memorial, shown here, was also dedicated to veterans of the Philippine-American War, the Chinese Boxer Rebellion and to those who served their country from 1898 to 1902. The Karkadoulias Bronze Art foundry cleaned and restored the bronze figures in 1985.

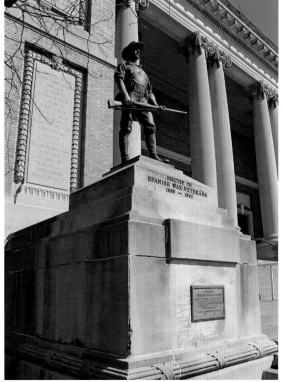

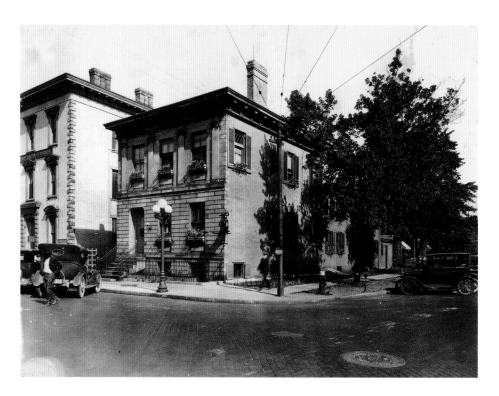

JAMES BROOKS RESIDENCE: Located on the corner of First and Jefferson Streets, this was the first brick house built in Dayton with a stone front. Later used as offices for interior decorators, music teachers and other businesses, the 1832 Greek Revival structure is thought to be Dayton's oldest continuously-used building. In 2014, the home is a private residence.

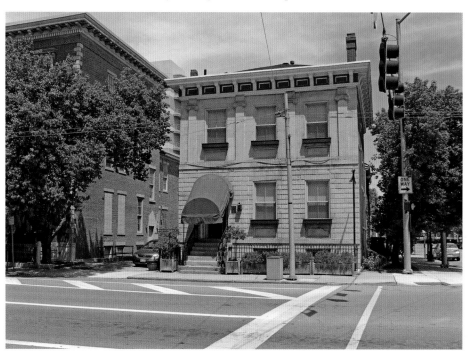

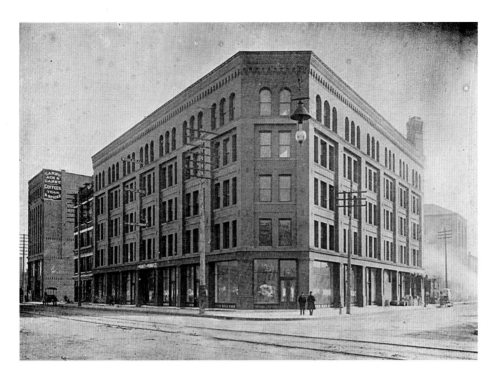

BARNEY POWER BLOCK: In the late nineteenth century specially designed power buildings leased space to tenants, usually workshops, which provided a centrally-powered line shaft to run their machinery. Constructed on the southeast corner of Third Street and Wayne Avenue in 1893, the building's first occupants included the Lowe Brothers Paint Company. The structure has become part of a six-building complex known as the Cannery, with retail businesses at street level and loft apartments above.

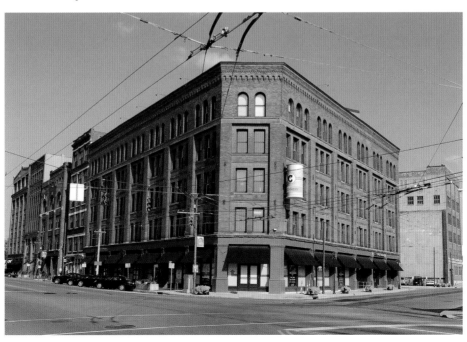

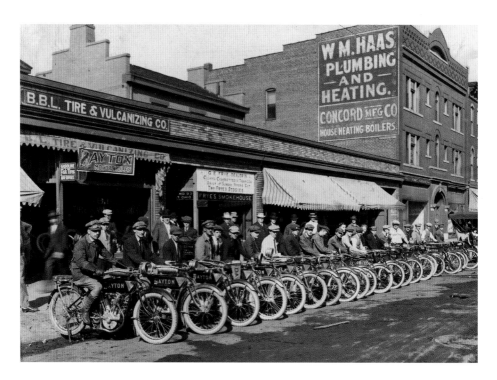

ROW OF DAYTON MOTORCYCLES, CIRCA 1916: Located at 421 East Third Street, BBL Company was the local seller of the Dayton Motorcycle and Dayton Motor Bicycle, both of which were locally made by the Davis Sewing Machine Company. Next door was Frye's Smokehouse, which sold cigars and other tobacco products, and further east was Haas Plumbing and Heating. In 2014, the entire strip is used by KK Motorcycle Supply, a wholesale distributor of accessories for street bikes, off-road motorcycles and all-terrain vehicles.

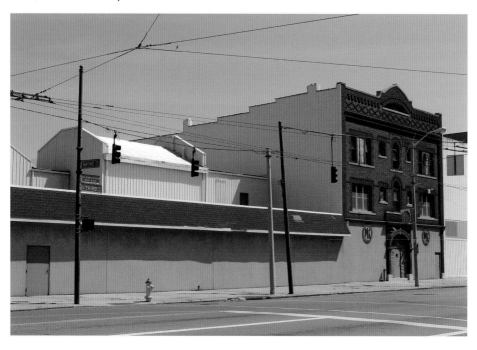

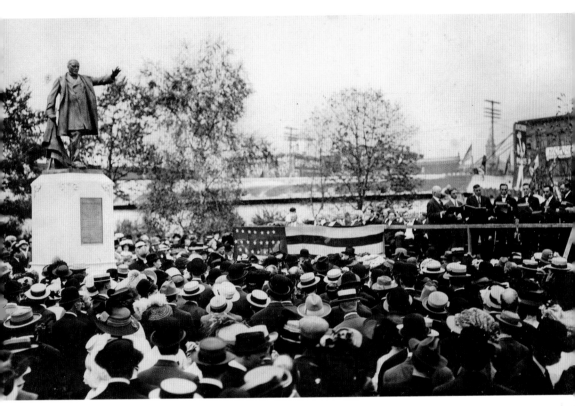

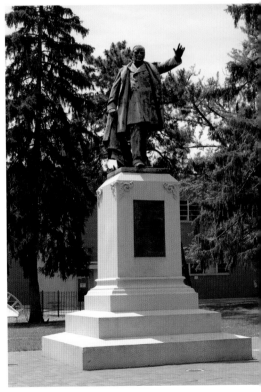

PRESIDENT WILLIAM MCKINLEY
MONUMENT: Located in Cooper Park, the bronze
sculpture was dedicated in 1910 to honor the
Ohio-born president who was assassinated on
September 6, 1901, by Leon F. Czolgosz at the Pan
American Exhibition in Buffalo, New York. Over
11,000 children donated money to erect the $4,000
monument. The monument was moved to its
present location after a new library building was
erected in 1962.

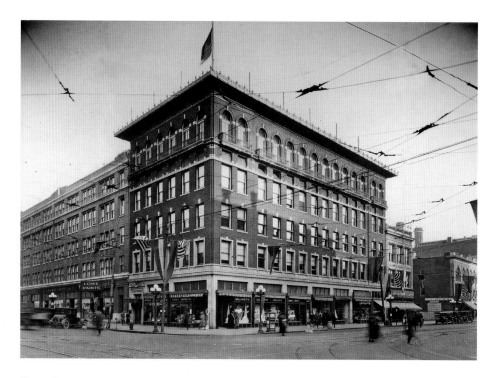

ELKS BUILDING: In November 1916, Ohio Governor-elect James M. Cox dedicated the new Benevolent and Protective Order of Elks Building on the southeast corner of Third and Jefferson Streets. In 1960, Dave Hall, who would become Dayton's mayor in 1965, bought the building and named it Sam Hall Apartments, after his son, a 1960 Olympic silver medalist in diving. Hall added a penthouse a year later. The structure was converted into an office building in 1986.

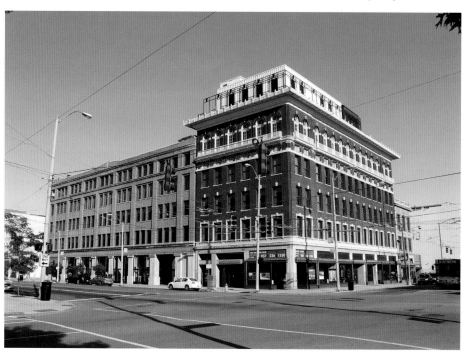

ODD FELLOWS TEMPLE:
Built in 1870, this Gothic Revival
stone building originally housed
the Odd Fellows Hall until
1920. Members were "bound to
charitable and beneficent works,
in visiting the sick, relieving the
distressed, burying the dead,
and educating the orphan." Still
located on the southwest corner
of Third and Jefferson Streets, the
building is almost unrecognizable
as such, at some time having lost
its top two floors.

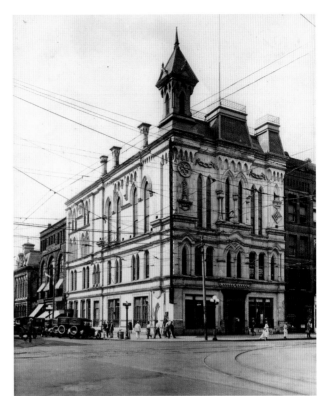

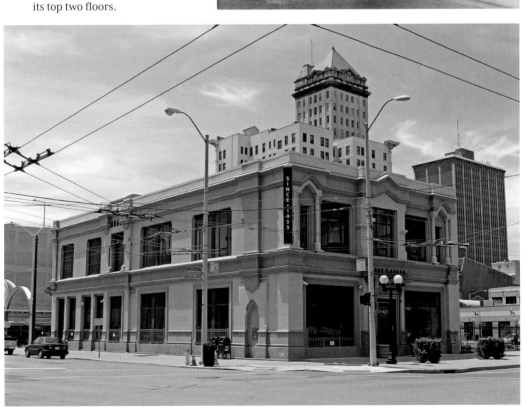

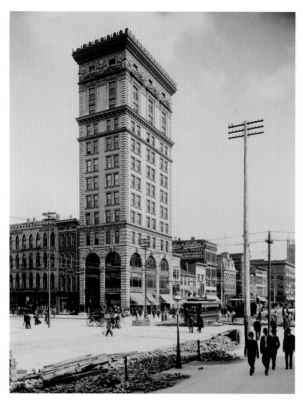

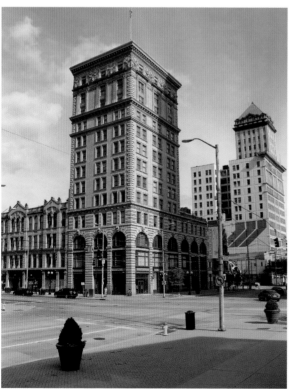

CONOVER BUILDING:
The southeast corner of Third and Main Streets has been used for commercial purposes for more than two centuries, beginning with the opening of a blacksmith shop by Obadiah Conover in 1811. The present structure was erected on the site in 1900. In the original building plans the architect, Frank Andrews, included an office for himself under an art glass rotunda on the thirteenth floor. The Conover was expanded in 1921 and 1926. It is known as the American Building in the early twenty-first century, having been renamed when The American Savings and Loan purchased it, before going bankrupt in 1921.

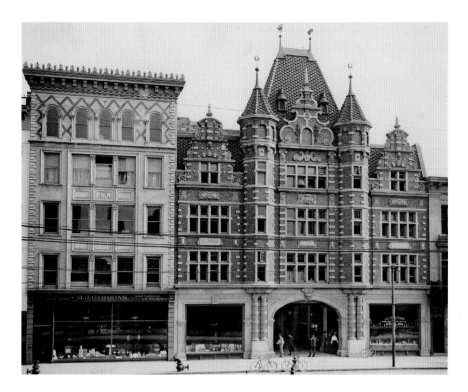

GIBBONS' ARCADE: The building first opened in 1904 to much fanfare, including caged animals from the Cincinnati Zoo. Adorned with a three-and-a-half-story Flemish-style façade, the Third Street entrance is patterned after a guildhall in Amsterdam. A 200-feet-long by twenty-feet-wide, glass-roofed, arched corridor allowed patrons to walk from Third Street to Fourth Street, with both entrances leading to the rotunda in the middle of the building. Once filled with merchants of all kinds, the Arcade has been closed since 1991.

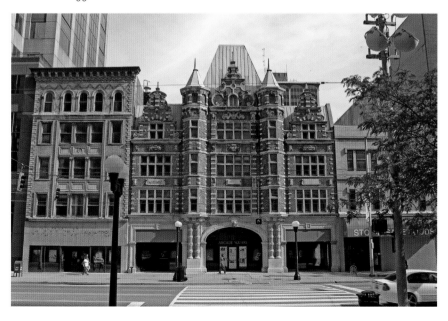

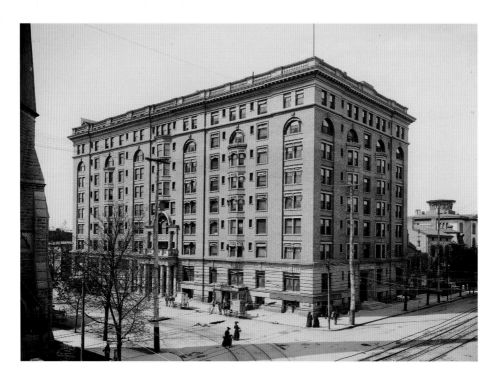

ALGONQUIN HOTEL: Originally opened as an apartment house at the southwest corner of Third and Ludlow Streets in 1898, it began operating as a hotel the following year. Due to the building's height the 300 guests stuck in the hotel during the 1913 flood didn't suffer much. The quick-thinking staff moved supplies onto higher floors as the water rose. The hotel's guests were probably the only people downtown who were served regular meals during the ordeal. In 2014, the building is the Dayton Grand Hotel.

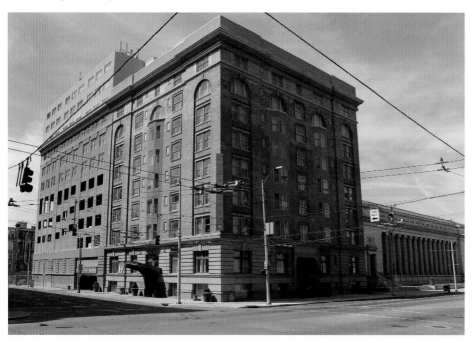

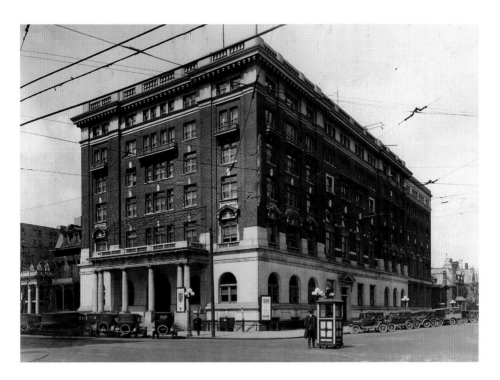

YMCA: Having outgrown their building on East Fourth Street, the organization erected this structure on the northwest corner of Third and Ludlow Streets. William Howard Taft, then secretary of war, came to Dayton for the laying of the cornerstone on April 29, 1907. Completed in 1908, the six floors included Turkish baths, sixty showers, a restaurant, bowling alley and game room. At the time it was the second largest YMCA building in the world. Yet twenty years later the YMCA had also outgrown this building. The structure is now City Hall.

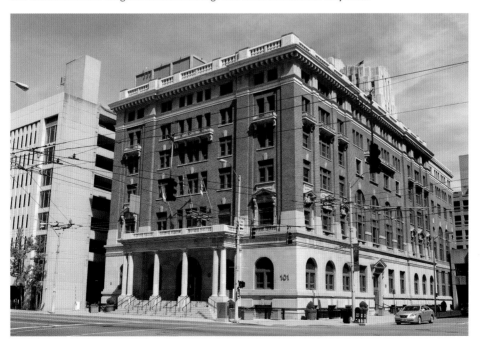

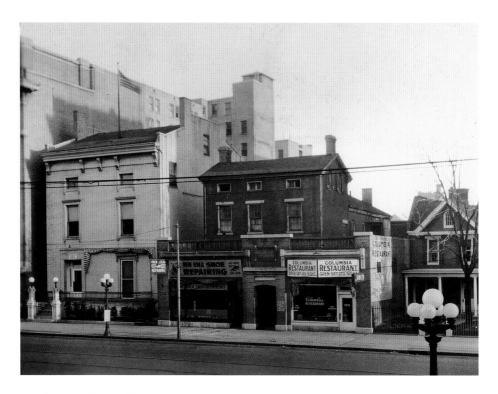

DR. EDWIN SMITH RESIDENCE: The home, seen here on the far left, is located at 131 West Third Street, between Ludlow and Wilkinson Streets. Constructed in 1850, it was sold in 1872 to lawyer Samuel Craighead. In 1915 it became home to the Dayton Bicycle Club, a private club which still uses the building a hundred years later.

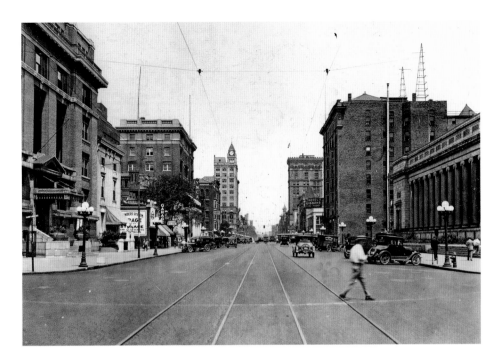

THIRD STREET: On January 1, 1915, the Old Post Office and Federal Building, located on the right, was dedicated at the southeast corner of Third and Wilkinson Streets. Called "The Grecian Lady of Third Street," the granite structure included a colonnade of sixteen monolith columns. Reliefs of eagles, wreaths and scrolls ordained the entrances while lion heads inspected those who passed by. But when the post office left in 1969, and the federal offices moved out in 1975, the building was slated for demolition. Fortunately, the building was saved and, in 2014, it is the US Bankruptcy Court.

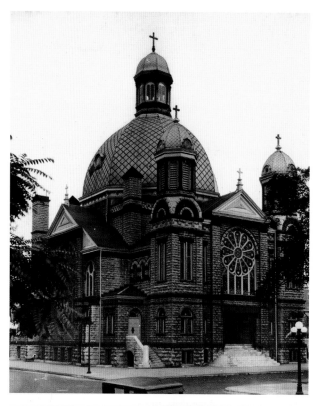

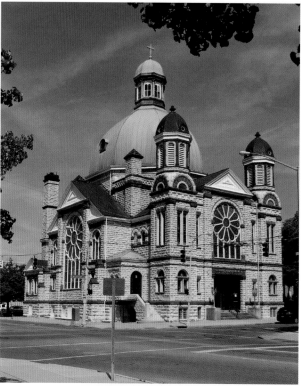

SACRED HEART CHURCH: In
1888, St. Joseph's Church became
crowded enough to have to divide,
and so the Sacred Heart Roman
Catholic Parish was organized. The
newly-formed congregation met
in various locations until 1895,
when this beautiful Romanesque
structure of Dayton limestone and
Berea brownstone was erected on
the northwest corner of Fourth and
Wilkinson Streets. Closed in 1996,
the church reopened in 2001 as
home to the Vietnamese Catholic
Community of Greater Dayton.

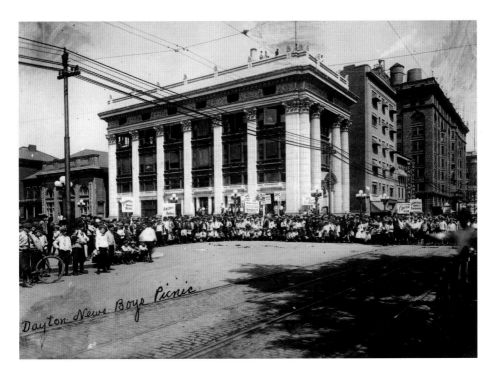

DAYTON DAILY NEWS: In 1898, James M. Cox bought the *Dayton Evening News* and changed its name to the *Dayton Daily News*. In 1910, Cox wanted a new building constructed at the northwest corner of Fourth and Ludlow Streets. After being turned down for a loan to erect the structure, Cox ordered that the Dayton Daily News building be designed to look like a bank, so it was modeled after the Knickerbocker Trust building in New York City. In 2014, the building is empty.

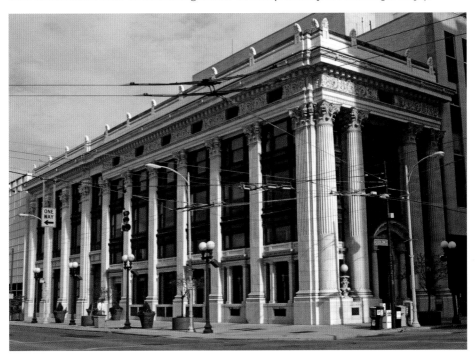

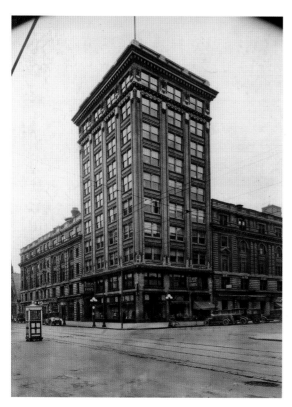

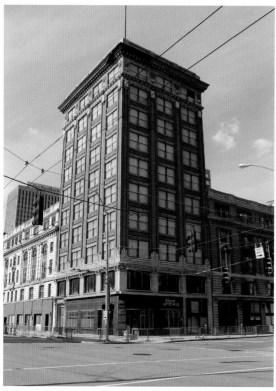

COMMERCIAL BUILDING: Located at the northeast corner of Fourth and Ludlow Streets, this ten-story structure fits into the corner of the Arcade building and is now considered part of the 260,000 square-foot complex. Designed by Dayton architect Albert Pretzinger for Adam Schantz Jr., the structure has a very distinctive Renaissance styling. The building has sat empty since the 1970s.

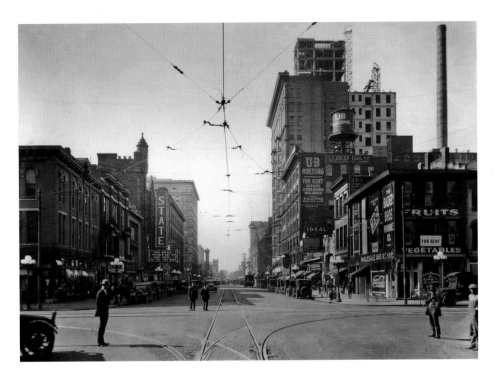

FOURTH STREET LOOKING WEST: This view, from Jefferson Street, shows the construction of a tower on the United Brethren Building on Fourth and Main Streets. Built in three sections, this was home to the UB Publishing House, well known for its publication of religious and devotional books. By 1924, a middle section and tower had been added, making the twenty-one story building the tallest reinforced concrete building in the world at the time. It has since been renamed the Centre City Building.

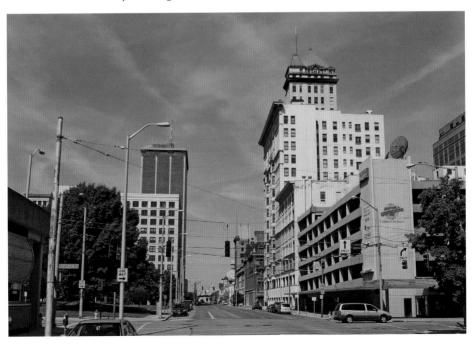

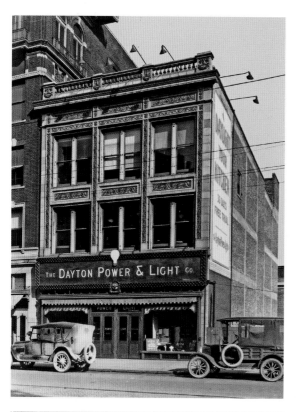

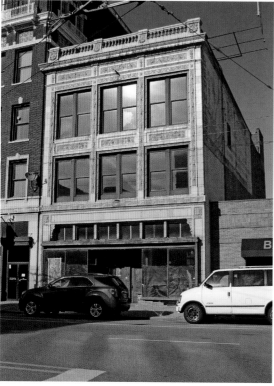

THE GAS & ELECTRIC SHOP:
Constructed in 1916, this terra-cotta
building at 18-20 South Jefferson was
used by Dayton Power & Light as both
a general office and a store front. The
company sold a complete line of gas
and electric appliances, focusing on
gas ranges, washing machines and
refrigerators; anything that would, in
essence, create a use for their services.
It is best remembered as the location of
Bernie's Music Center, which closed in
1993. It is hoped that the building can be
repurposed in the future, but nothing is
planned as of 2014.

HOME TELEPHONE BUILDING:
In 1902, over 5,000 telephone
subscribers eagerly awaited the
new automatic telephone exchange
being installed by the Home
Telephone Company in their new
building at 52 South Jefferson
Street. The company would later
become the first client of L. M.
Berry, of *Yellow Pages* fame. Home
Telephone became part of the
Ohio State Telephone Company in
1914, which became the Ohio Bell
Telephone Company in 1921. Since
1950, the building has been the
home of Price Stores, known for
their men's clothing and bridal and
tuxedo shop.

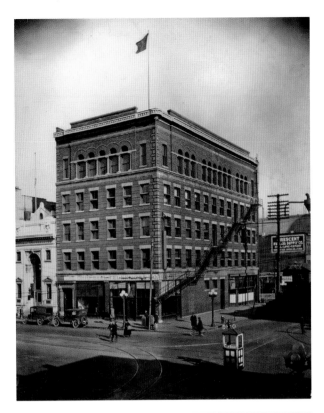

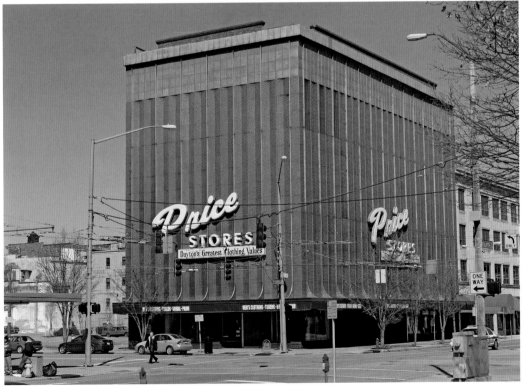

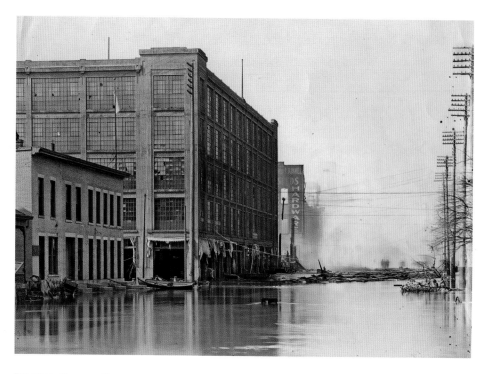

BEAVER POWER BUILDING: Located on the northwest corner of Fourth and St. Clair Streets, this was built by Frederick Phillip Beaver in 1898. It was here in 1911 that the Dayton Engineering Laboratories Company, the original Delco, began manufacturing the first electric self-starters for automobiles. The reinforced concrete structure houses St. Clair Lofts, a 108-unit apartment building in 2014.

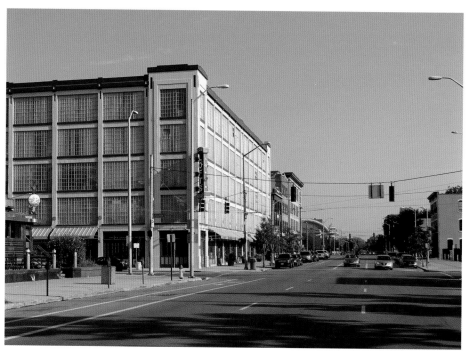

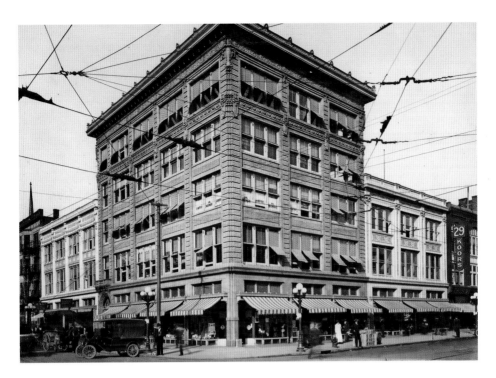

THE LUDLOW BUILDING: Located on the northeast corner of Fifth and Ludlow Streets, this is one building disguised as three. The three parts consist of a brick and terra cotta five-story structure on the corner, flanked by three-story terra cotta structures facing Ludlow Street and Fifth Street, respectively. Built in 1917, the building was in disrepair until renovated by Reynolds & Reynolds in 1994-1996 for use as a training center and offices. Since 2003, the property has been used for offices by Dayton Public Schools.

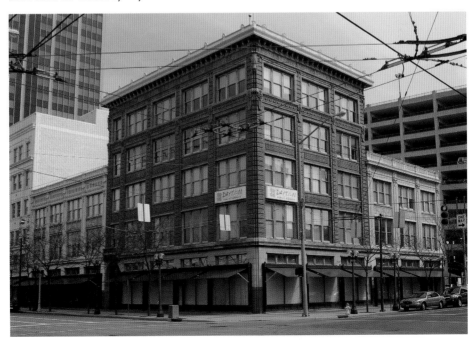

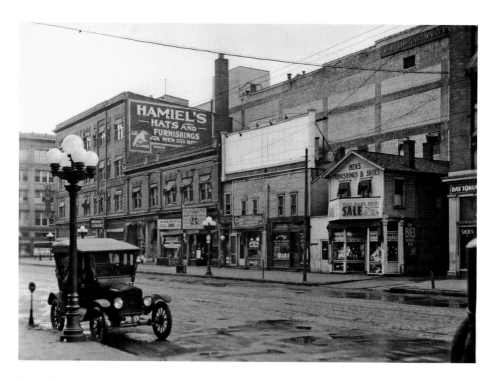

EAST SIDE OF LUDLOW STREET: The Christian Publishing Association building at the far left was erected at the southeast corner of Fifth and Ludlow Streets in 1905. Hamiel Hat Company began renting the building the same year. Although Hamiel's closed after the owner's death in 1932, a ghostly image of the company's advertising still remains. Now known as the Ludlow Place building, the structure underwent a beautiful renovation in 2014.

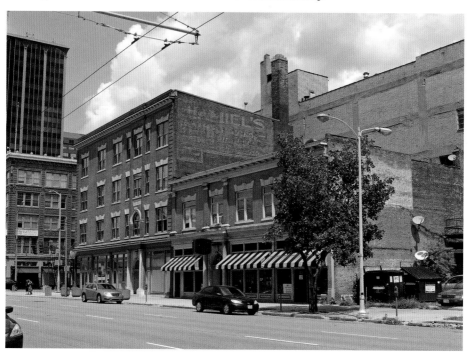

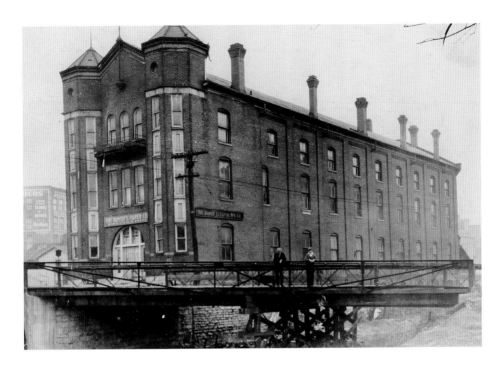

ARMORY BUILDING: Located at 201 E. Sixth Street, this building was dedicated on February 23, 1894. Up to that time the two local companies of the Ohio National Guard – the Phoenix Light Infantry, Co. G, and Gem City Light Infantry, Co. I. – had been housed in various halls about the city. None were made well enough for the safe storing of guns and ammunition, or strong enough for the drilling exercises of the regiments, so the state agreed to build them a more modern structure. Almost razed during the grading of Patterson Boulevard, since 2000 it has been the offices of Gottschlich & Portune, LLP.

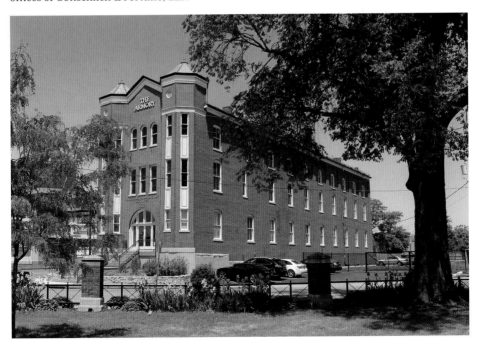

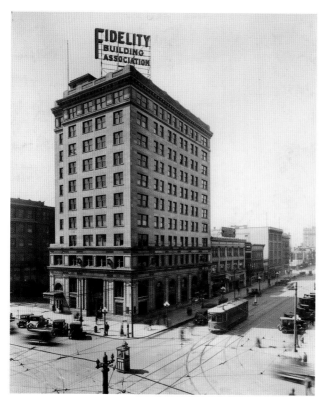

FIDELITY BUILDING: Built on the southwest corner of Fifth and Main Streets in 1918, this was also known as the Medical Building due to the fact that most of the tenants were either physicians or dentists. It was also home of the Fidelity Pharmacy and one section was set aside for a medical library. This Neoclassical style building was expanded to its present size in 1929. In 2014, the building is mostly vacant, but there is hope that it can be redeveloped and reopened sometime in the future.

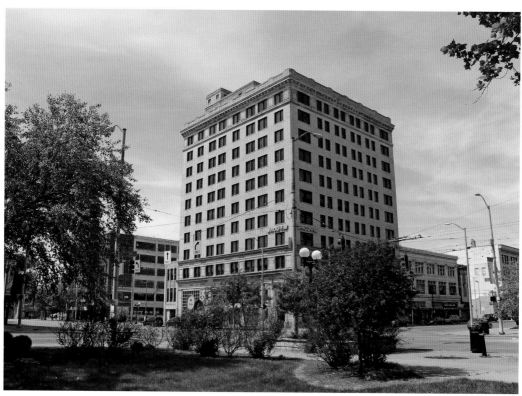

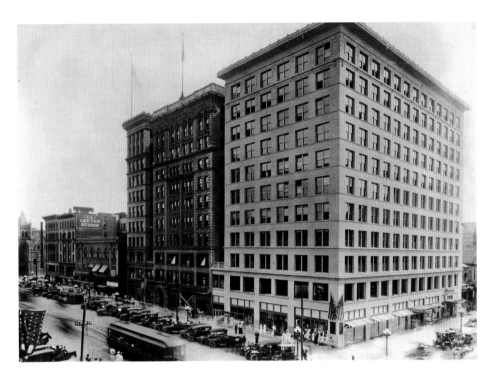

REIBOLD BUILDING: Located on the southwest corner of Fourth and Main Streets, the building was erected in three sections, from 1896 to 1914. The city's first escalators were installed there in 1934. Bought by the county for use as government offices in 1972, plans were made to cut off the building's top six floors. Luckily, this was not done. In 2002, the county spent nearly nine million dollars in renovations, which included restoring the terra cotta and brickwork on the eleven-story building.

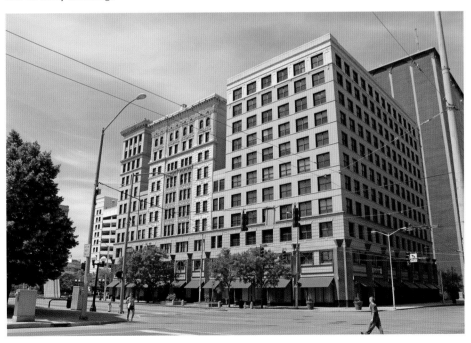

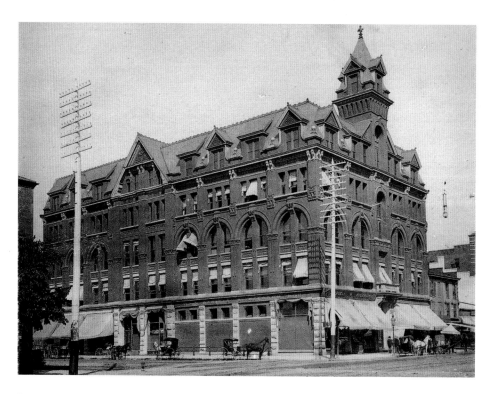

BENJAMIN F. KUHNS BUILDING: This Romanesque Revival building on the northeast corner of Fourth and Main Streets was completed in 1883. The central tower was destroyed by a fire in 1947. Once home to companies such as the Manhattan Clothing Store and Oleman's Department Store, the building has since been turned it into a beautifully renovated mixed-use office building.

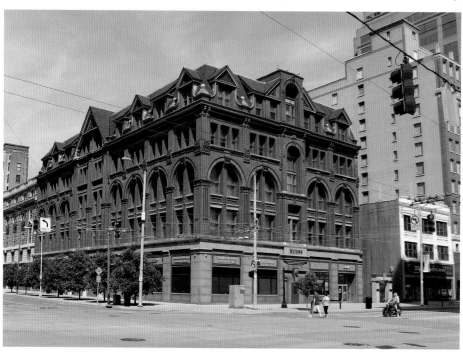

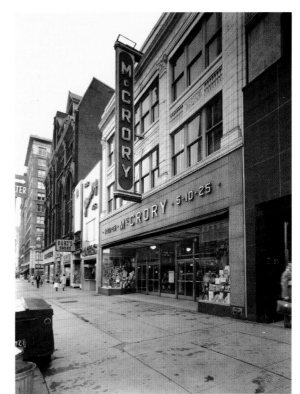

MCCRORY'S: When John Graham McCrorey began his chain of stores, he dropped the "e" from his name in order to save the cost of the extra letter on his store signs. The first Dayton location opened at 29 South Main Street in 1925. The L-shaped building had entrances at both Main and Fourth Streets, as well as an opening into the Arcade. Although a five-and-dime, it had a reputation of having high-class merchandise. The store closed in 1997, but reopened as Suney's Beauty and More in 2008.

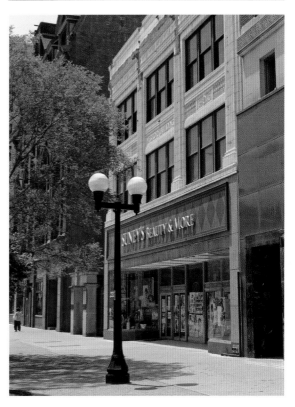

39

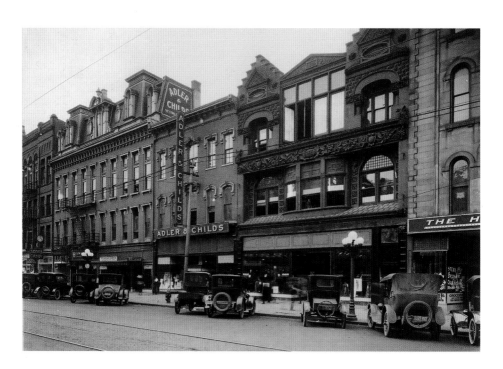

LAFEE'S TEMPLE: Originally located at 22 East Third Street, this building is downtown's last surviving example of the cast-iron storefronts manufactured in the nineteenth century by Dayton's McHose & Lyon Co. Erected in 1886 by Paul A Lafee, the building's terra cotta and cast iron façade includes unusual faces, gargoyles, owls and dragons, as well as the name of its original owner. In 1987, the building was razed to make way for a parking lot, but fortunately the façade was saved. In 2001, when RTA bought the American Building for their new bus hub, the façade was incorporated into the design and relocated to 20 South Main Street.

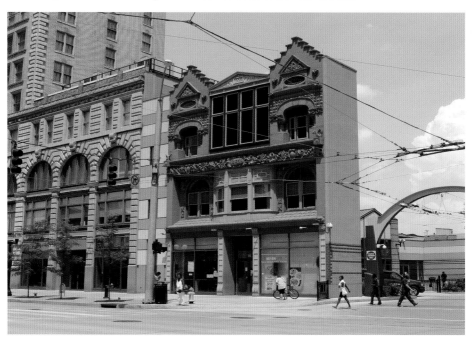

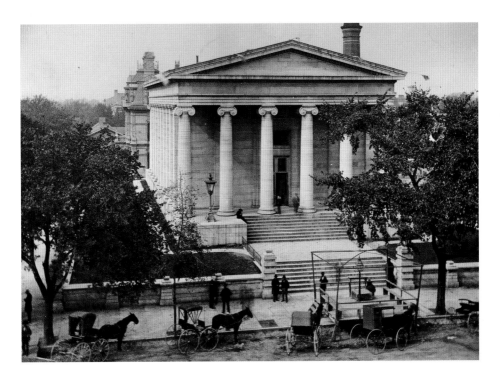

OLD COURT HOUSE: Built in 1850, on the northwest corner of Third and Main Streets, the structure is considered one of the finest examples of Greek Revival architecture in the United States. It is here in 1859 that Abraham Lincoln first announced his candidacy for president. The Old Court House is open to the public through tours and special programming, including mock trials of old murder cases.

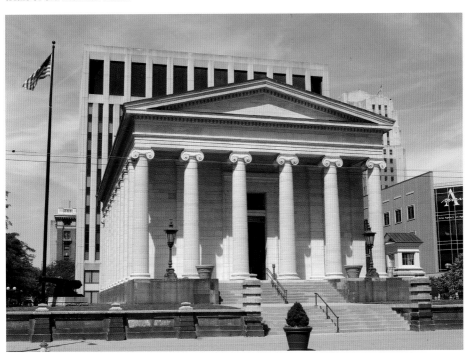

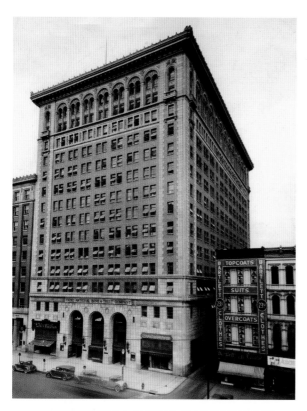

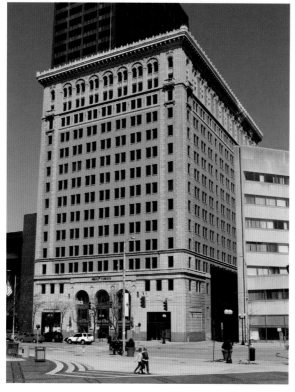

THIRD NATIONAL BANK AND TRUST COMPANY: Until the company was sold in 1984 to Society Bank, it had the distinction of being the oldest national bank in the United States, having been in continuous operation since 1863. In 1926, the bank moved to its new building at 34 North Main Street. The building was finished throughout with imported marble and mahogany woodwork and bronze check desks. The structure was renamed the Paru Tower in 2010.

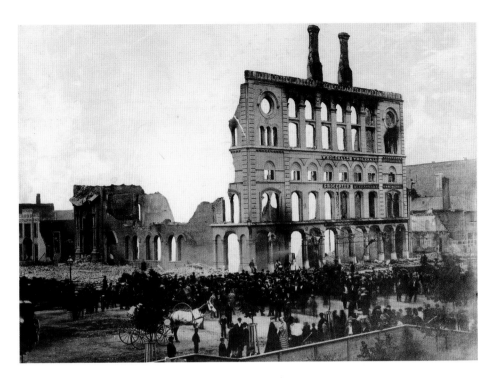

TURNER OPERA HOUSE: Opening at the southeast corner of First and Main Street in 1866, a fire in 1869 left behind only the front façade. Most of the façade was reused when the building was rebuilt as the Music Hall in 1871, but it was shortened by two floors. Over the decades the theater presented plays, vaudeville acts and motion pictures. Renamed the Victoria in 1990, the theater continues to entertain audiences with traveling Broadway shows, concerts, and other theatrical productions.

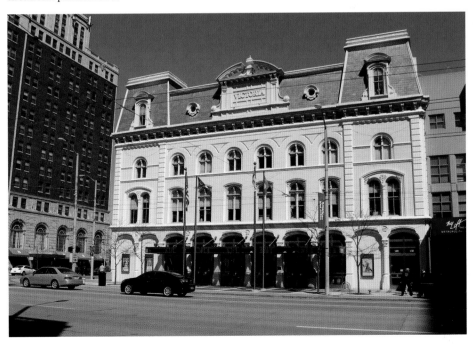

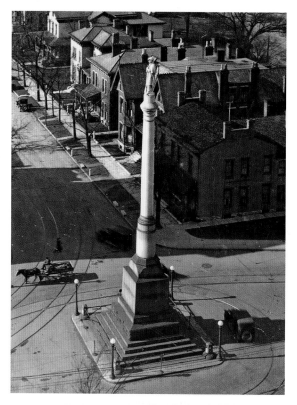

SOLDIERS' MONUMENT: Atop the column stands a likeness of Private George Washington Fair, a Union Army private during the Civil War. Built in 1884, the monument was moved from its original site on Monument Avenue to Riverview Park in 1948, after being deemed a traffic hazard. In 1991 it was moved back downtown, mid-block, between Monument Avenue and First Street, just a few yards from its previous location. At that time the original marble figure of Private Fair was replaced with a more durable bronze replica. The marble statue stands guard in front of the hospital at the Dayton VA Medical Center on West Third Street.

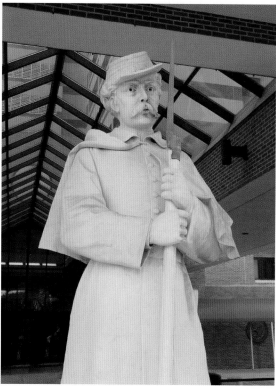

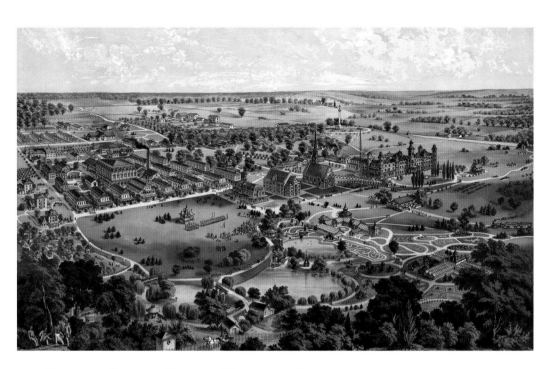

NATIONAL HOME FOR DISABLED VOLUNTEER SOLDIERS: The Dayton Soldiers' Home was established on March 26, 1867, to provide care for Union volunteer soldiers who were disabled during service in the Civil War. With its broad avenues, beautiful lakes, flower gardens, library, church and other buildings, the Home became so popular it attracted thousands of visitors annually, with groups hundreds of miles away taking chartered train trips to Dayton. Renamed the Veterans Affairs Medical Center in 1989, it is located on the southwest corner of Third Street and Gettysburg Avenue.

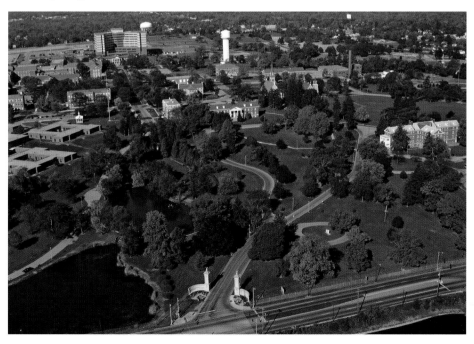

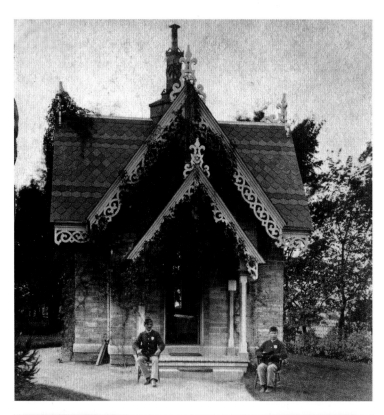

THE GUARDED LODGE: The first building visitors to the Soldiers' Home would see was the Gatekeeper's Lodge. Built in 1868, the Gothic Revival-style structure was manned by veterans, who would greet visitors by saluting them. Veterans who acted as guides to the Home were designated with badges.

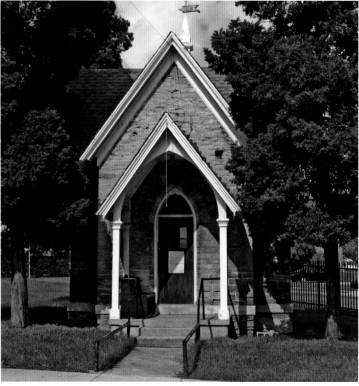

PROTESTANT CHAPEL: Dedicated on October 26, 1870, the Gothic structure, built of dark gray limestone quarried at the Home, was the first permanent government-constructed place of worship in the United States built for veterans and by veterans. Six years later a large bell was hung in the tower. The inscription read: "1776, Centennial Bell, 1876, made for the Church of the National Soldiers' Home, Dayton, Ohio, from cannon captured from the enemy during the War of the Rebellion." Chapel services are still held there on Sundays.

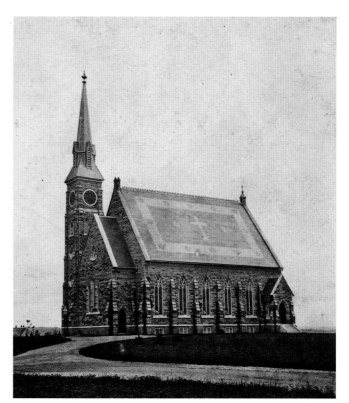

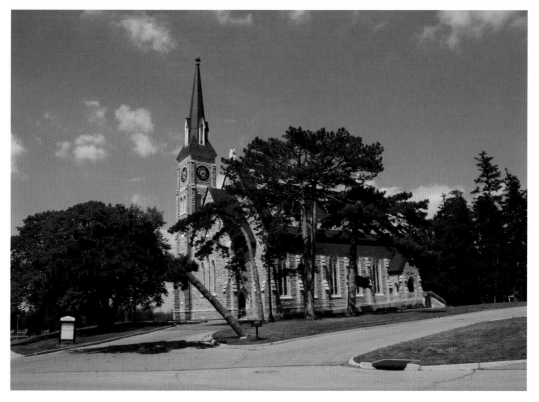

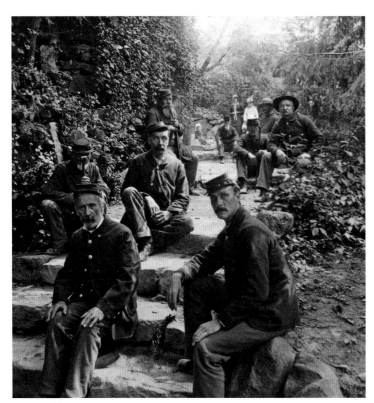

CIVIL WAR VETERANS RELAXING: One of the reasons visitors were drawn to the Soldiers' Home was because of the reputation of its Grotto, with its beautiful foliage and waterfall. A stone archway, seen on the left in the stereo-view, stood guard over a set of steps that led down to where visitors were lulled into relaxing by the sound of falling water. Below, modern-day Civil War reenactors take a short rest near the entrance of the newly restored Grotto.

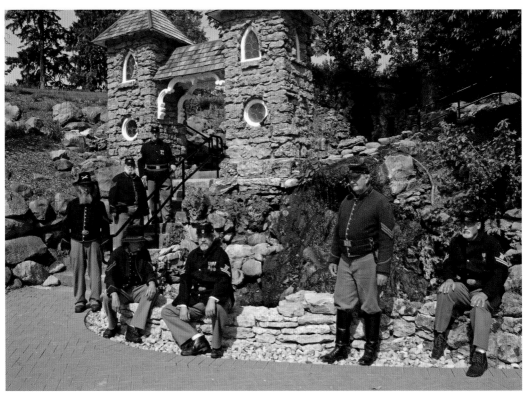

LAKE AND BOAT HOUSE: Another chief attraction at the Soldiers' Home was the lakes. There were four in all, which together covered over six acres of ground and contained nearly 20,000 barrels of pure water, supplied by springs. The Big Lake was the eastern boundary of the grounds, and the others extended to the west. The waters swarmed with fish, many of which could be seen by visitors who took advantage of renting a boat for a leisurely ride around the lakes. Boats are no longer available, but the boathouse still provides a quiet place to relax.

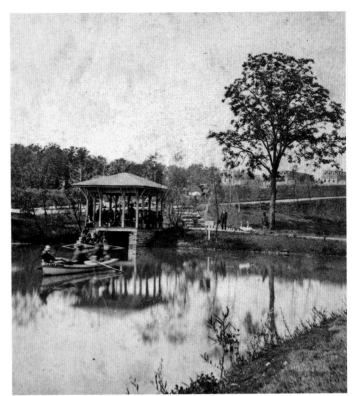

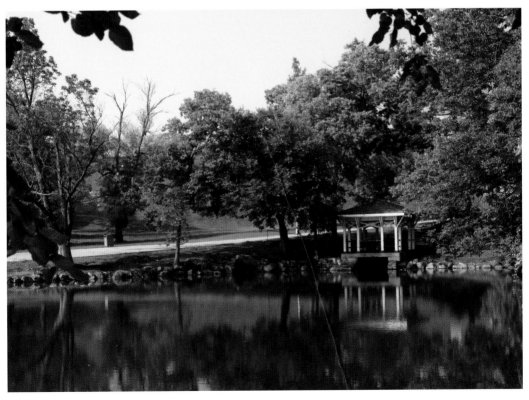

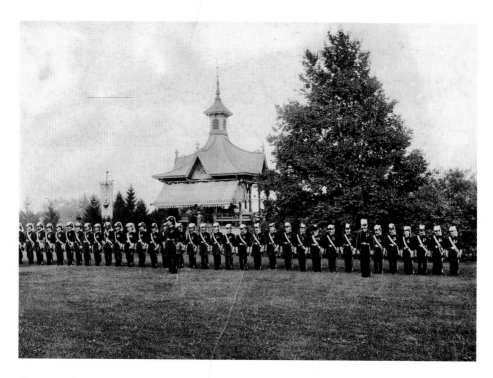

SOLDIERS' HOME BAND STAND: Above, members of the Reed Commandery, No. 6, Knights Templar, stand in front of the band stand, *circa* 1890. Built in 1871, the band stand was the central focus of the parade grounds. Gas lights illuminated it during evening hours, allowing visitors to see the musicians, and the musicians to see their sheet music. The band stand continues to be used for the occasional event and as a place for quiet reflection for both residents and visitors alike.

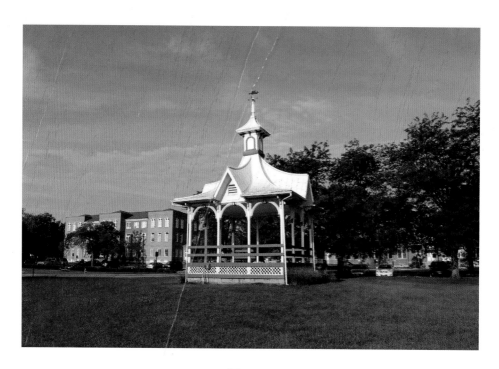

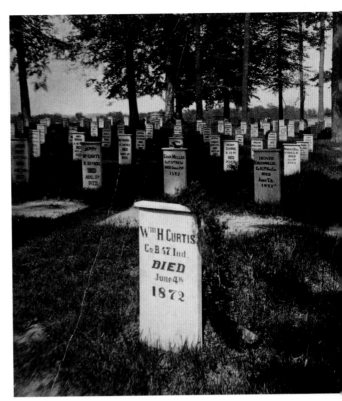

SOLDIERS' HOME CEMETERY:
When a soldier died at the Home he was buried with military honors. The body would be placed in a flag-covered casket and taken through the funeral tunnel that led to a beautiful grove near the northwest corner of the grounds, which had been laid out for a cemetery. The Home band would play solemn music while the funeral procession followed the soldier to his final resting place. At first the gravestones were made of wood, but in 1873 it was decided to use white marble markers instead.

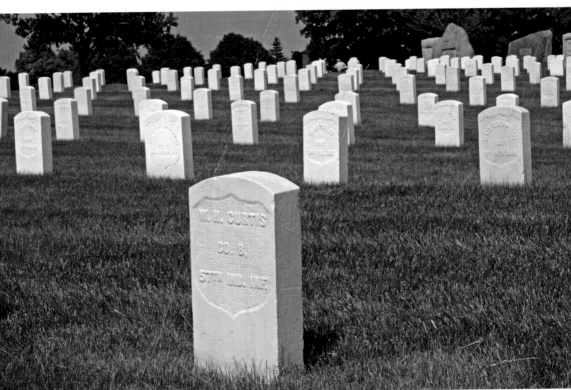

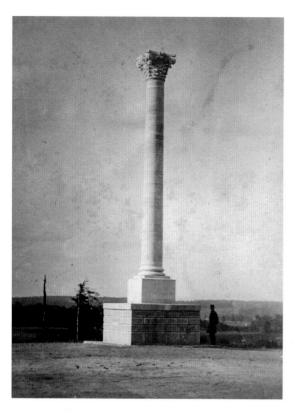

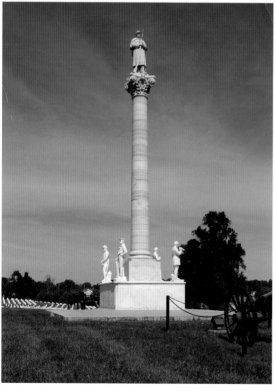

MONUMENT: In 1873, a memorial monument was begun to honor the heroic dead in the Soldiers' Home's Cemetery. A thirty-foot marble shaft, one of the columns of the United States Bank in Philadelphia, was selected, and then crowned with an ornamental cap. Four years later, a United States infantry soldier standing at parade rest was placed on top. It was unveiled on September 12, 1877, by President Rutherford B. Hayes in front of 25,000 visitors. Soon after, four military figures representing the Infantry, Cavalry, Artillery and Navy, were also added.

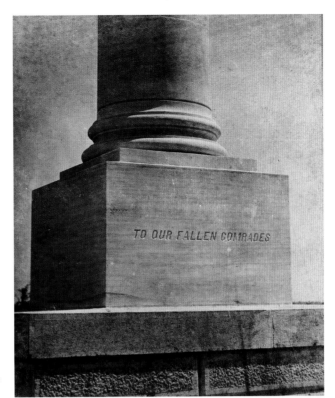

BASE OF MONUMENT:
A number of interesting items were placed under the cornerstone, including thirty-six stereo-views of the Home, a five dollar Confederate note and a rebel shell from the Gettysburg battlefield. Inscribed across the base are the words "To our fallen comrades – These were honorable men in their generation."

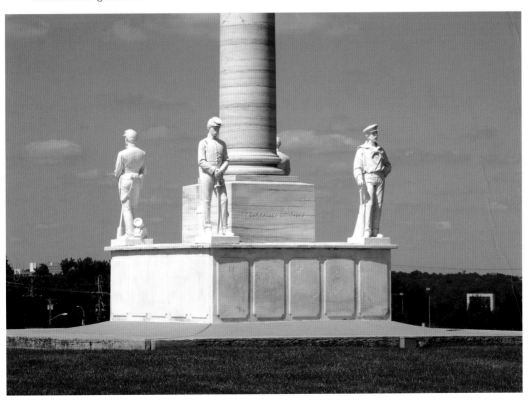

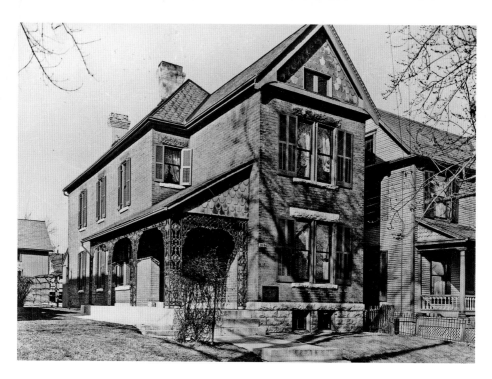

DUNBAR HOUSE: This home was the final residence of Paul Laurence Dunbar (1872-1906), who is generally regarded as the first black American to achieve distinction in the literary field. In 1936, the Ohio Legislature dedicated the house as a memorial to Dunbar, the first state memorial in Ohio to honor an African-American. Located at 219 Paul Laurence Dunbar Street, the museum exhibits his books, plays and other works, as well as many of his personal items and family's furnishings.

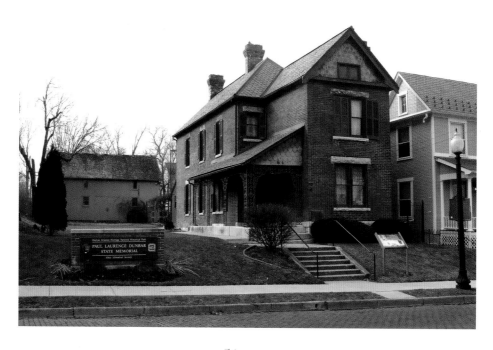

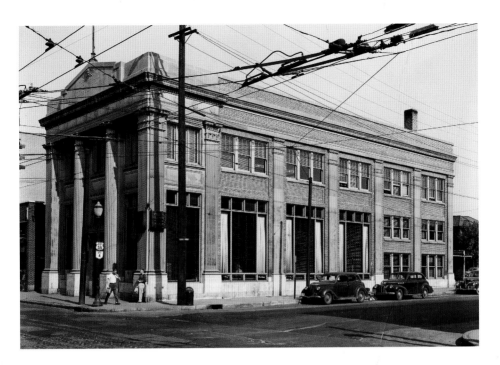

WEST SIDE BUILDING & LOAN ASSOCIATION: In 1922, the company moved into their new three-story brick building at the southeast corner of Third and Broadway Streets. And, to make sure that everyone knew who owned the $100,000 edifice, the company had its name carved in stone, just below a relief of an eagle. But in 1938, West Side B. & L. moved out and Winters National Bank & Trust Company opened a branch at the location. In 2014, it is owned by Chase Bank. And, sometime along the way, both the name and the eagle of the original company were chiseled off the front of the building.

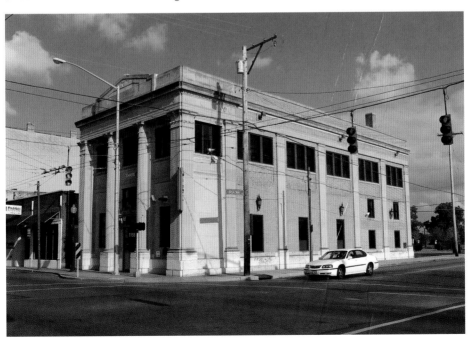

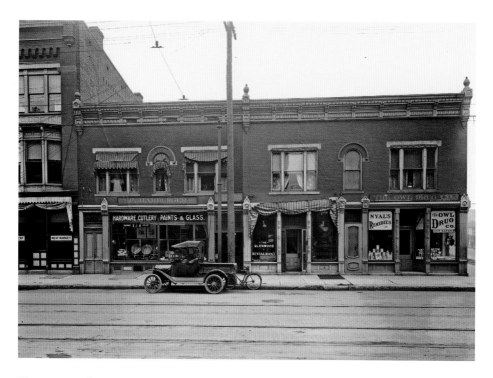

HAMBURGER'S: In 1898, Frank Hamburger opened a hardware store in the newly constructed building on the northwest corner of Third and Williams Streets. W. C. Fouts, whose pharmacy was part of the Owl Drug store chain, soon joined him. Although they changed owners over the years, both businesses would remain at this location for several decades. In 2014, the building's tenants include Sweet Dots and Wright Dunbar, Inc.

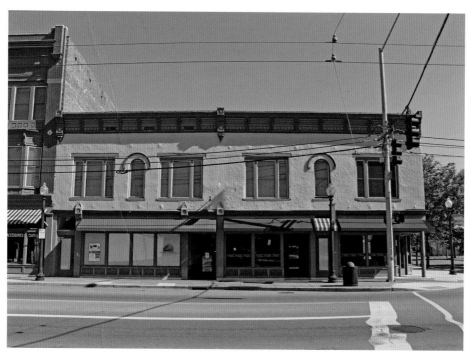

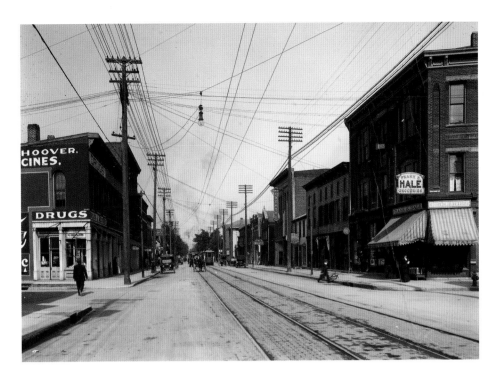

THIRD STREET LOOKING EAST FROM WILLIAMS STREET: On the southeast corner is the Hoover Block Building. Orville and Wilbur Wright would move their printing business into the newly constructed building in 1890. Further down can be seen the Fish Market building, the Pekin Theatre and the Midget Theater. As can be seen, much of this block still exists and is part of the Wright-Dunbar Business District.

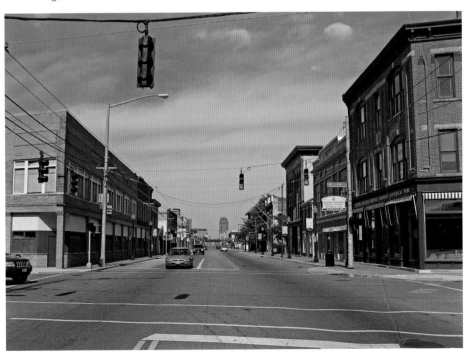

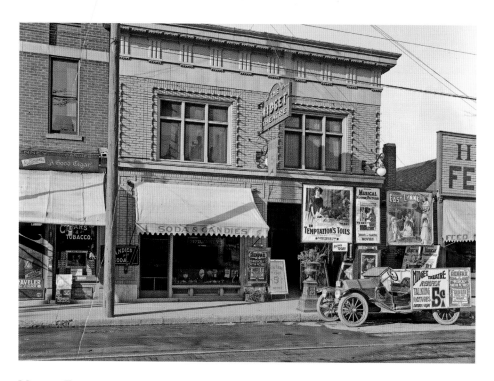

MIDGET THEATER: This theater was named in honor of Sherman W. Potterf, who was a "midget" and managed the theater. The owners took advantage of Sherman's height by advertising that there was "Nothing small about the Midget - Only the manager." Just as many people went to the theater's grand opening on September 6, 1913 to get a glimpse of Sherman as to watch the movie being offered. The building still stands at 1019 West Third, one of the few remnants left of the days of the nickelodeon theaters.

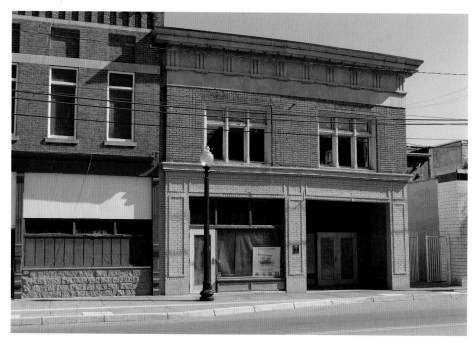

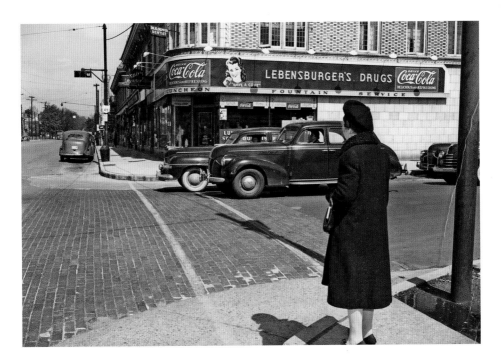

LEBENSBURGER'S IN 1945: Isaac (Ike) M. Lebensburger opened his drug store on the northeast corner of Salem and Grand Avenues in 1927. Known as "The Store Your Doctor Recommends," Lebensburger's was everything a drug store should be. Along with a pharmacy, the store had a soda fountain where lunch was served, and a wide selection of household products, candies, cigars, magazines and, of course, comic books. Although Lebensburger's closed in 1947, the location would remain a drug store for many years. In 2014, the site is a part of an apartment complex for seniors.

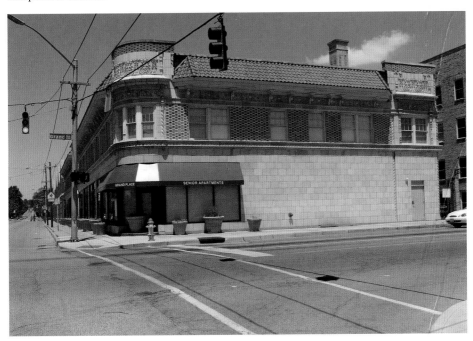

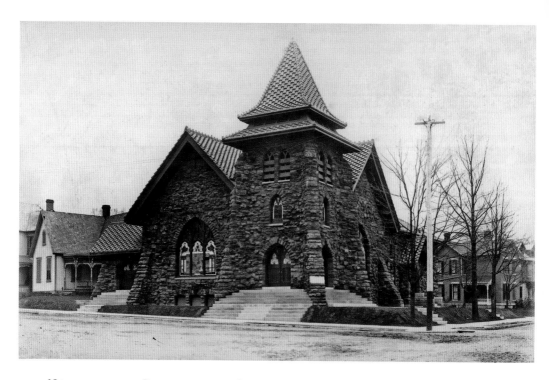

NORTHMINSTER PRESBYTERIAN CHURCH: Founded in 1884 as the Riverdale Mission Sunday School, it was renamed the Forest Avenue Presbyterian Church when this building was completed at 301 Forest Avenue in 1902. It took on its present name in 1970. Northminster held its final service in 2002. With its elegant red sandstone façade and Tiffany Art Glass windows, it is an outstanding Dayton landmark.

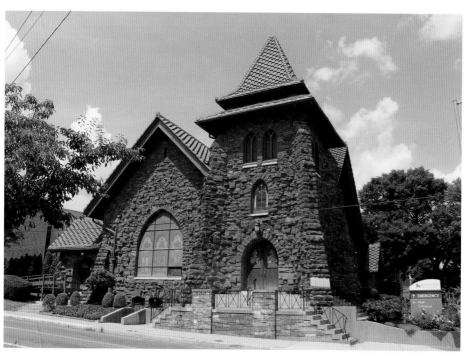

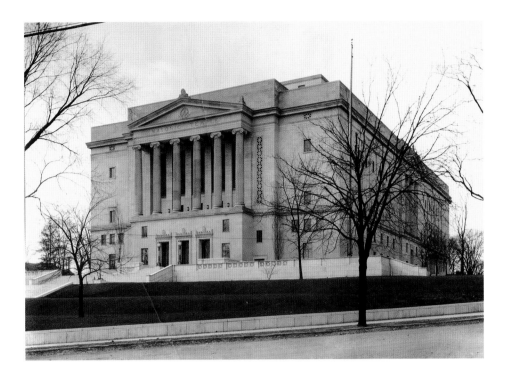

MASONIC TEMPLE: Completed in 1928, this six-story high temple at 525 West Riverview Avenue contains 250 rooms, a 1,900-seat cathedral and a 2,000-seat dining room. The massive building consists of twenty railroad carloads of Vermont, Alabama and Tennessee marble and took 450 workmen almost three years to complete. Later renamed The Masonic Center, the beautiful building remains one of the more impressive structures in Dayton.

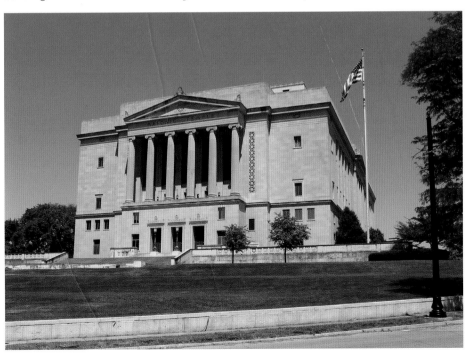

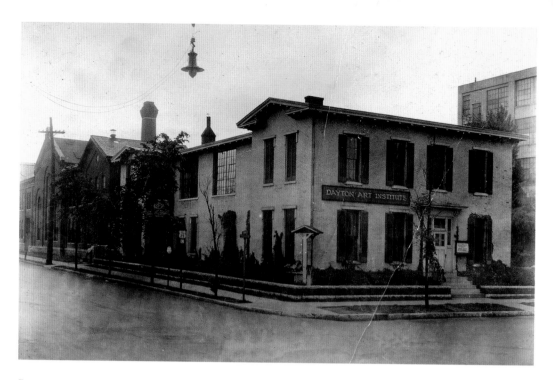

DAYTON MUSEUM OF FINE ARTS: Founded in 1919, the organization's first building was in the old Kemper home on the southeast corner of St. Clair Street and Monument Avenue. Renamed The Dayton Art Institute in 1923, the organization began an art-lending program, perhaps the first in the country. A gift of two million dollars by Julia Shaw Patterson Carnell allowed a museum to be built on Forest and Riverdale Avenues in 1930. The Italian Renaissance-style building is as beautiful as the artwork that hangs in its many galleries.

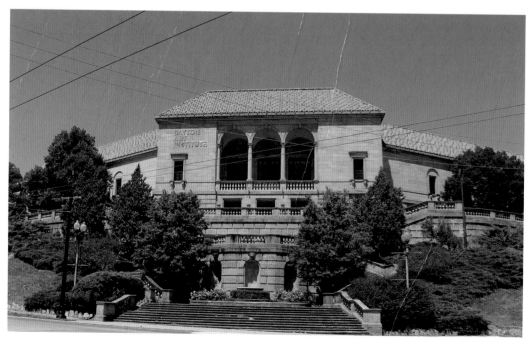

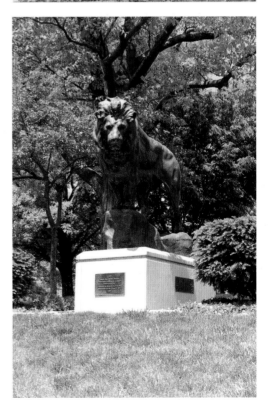

LEO THE LION: Steele High School's mascot, a lion cast in bronze, was sculpted in 1908 by Anna Hyatt Huntington. Money for the figure came from hundreds of young students who raised over $300 in nickels. Huntington modeled the piece in Naples, her inspiration being a lion she saw at the Bronx Zoo in New York. Steele High School closed and the venerable lion was moved in 1955 to stand guard outside the Dayton Art Institute.

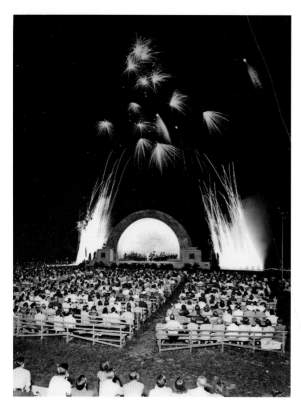

DIEHL BANDSHELL: Built near the end of the Great Depression in 1940 as a WPA project, this beautiful art deco bandshell was named after civic leader Leslie L. Diehl. The bandstand is located in Island MetroPark, at 101 East Helena Street. The park also provides a water-play area and gathering place for picnics and family fun.

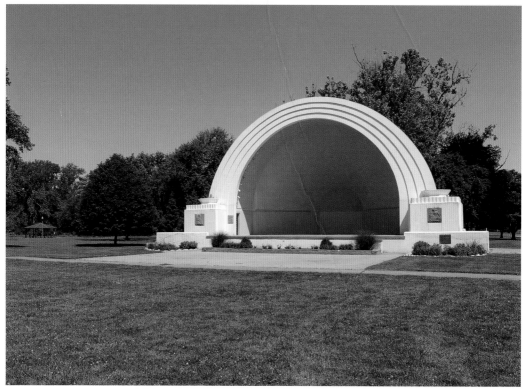

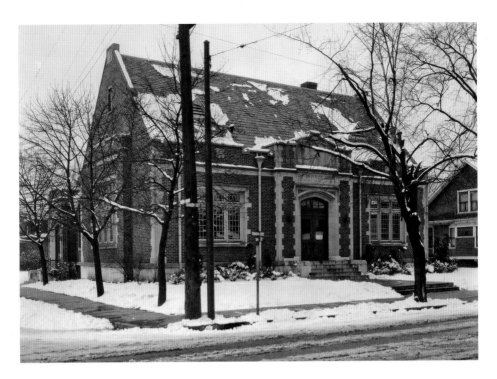

E. C. DOREN BRANCH: This library is named after Electra C. Doren, who served as chief librarian for the Dayton Public Library from 1896 to 1905. During her tenure she oversaw a major reorganization during which all items were first classified under the Dewey Decimal System. This allowed patrons to freely browse for books on their own, instead of having to ask a library clerk to retrieve books for them. Dedicated in 1928, at 701 Troy Street, it is the oldest branch in the library system.

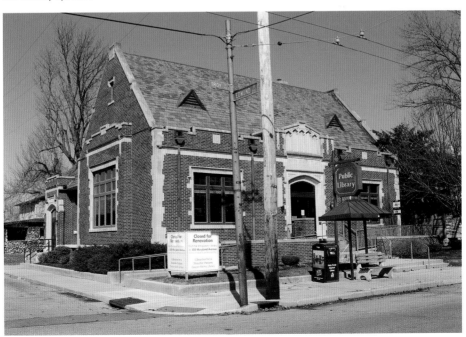

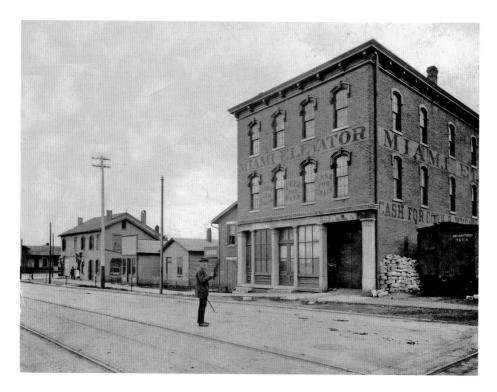

MIAMI ELEVATOR: Built about 1877, on Keowee Street, north of First Street, the building originally served as a grain storage and warehouse. In 1938, it was repurposed by Gem City Elevator Works, who manufactured hand-powered and automatic elevators. In 2014, the warehouse is owned by the Lesco Manufacturing Company.

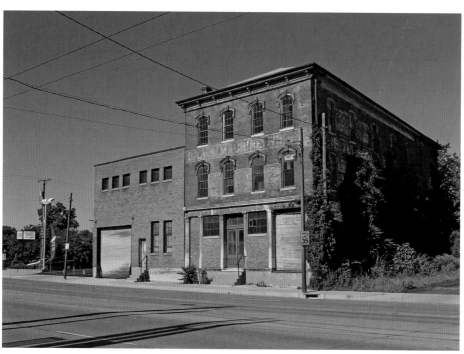

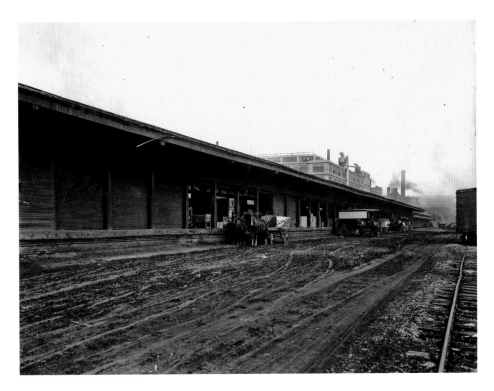

B & O RAILROAD STATION: This block-long brick building originally served as a railroad freight house when it was first built in 1911. Located at the corner of Second and Webster Streets, it is now known as 2nd Street Market. Consisting of more than forty local growers, bakers, artisans and other vendors, it was voted "Best of Ohio" by Ohio Magazine in 2014.

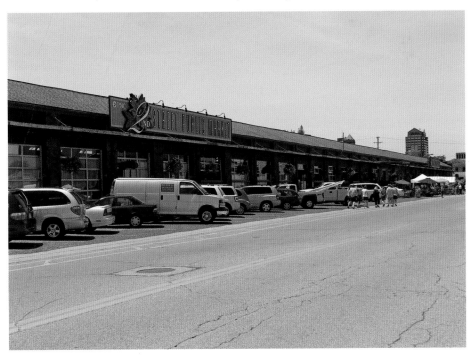

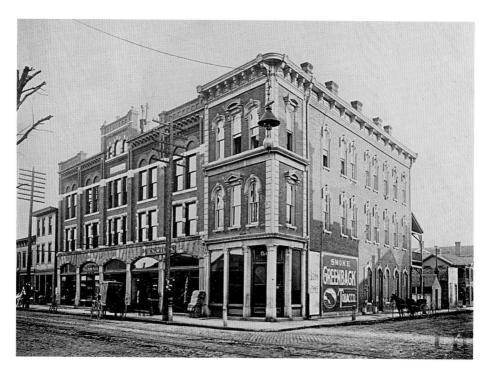

FIFTH & JACKSON STREETS: On the southeast corner stands the Moses Glas Building. Built in 1876, it was both the business of, and home to, Moses and his family for over forty years. He was well-known for making and selling great cigars. The Cicero Law Office is now located there. Next door is the Ware Block building. Among the merchants in 1893 was H. N. Wiles & Co., who dealt in dry goods. In 2014, the building's tenants include Dayton's oldest used bookstore, Bonnett's, which has been family owned and operated since 1939.

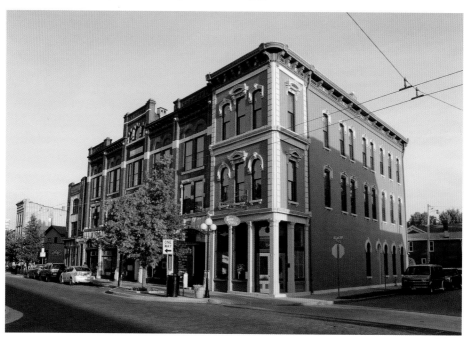

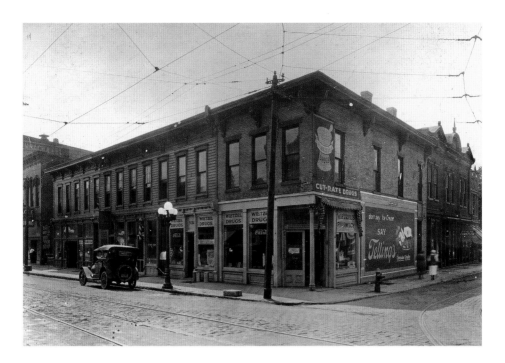

WIETZEL DRUGS: Built in 1850, by 1923 this building at the southeast corner of Fifth and Brown Streets included a pharmacy, barber shop, a delicatessen and a laundry. Wietzel started his drug store there in 1900. His motto was "Everything in Drugs," which included several patent medicines he made himself. His most popular item was "Wietzel's Stomach and Bowel Tonic," which claimed to help indigestion, improve the appetite and even clear up the user's complexion. Since 2013, it's been the home of Salar Restaurant, whose wonderful food offers a more conventional way to regain your appetite.

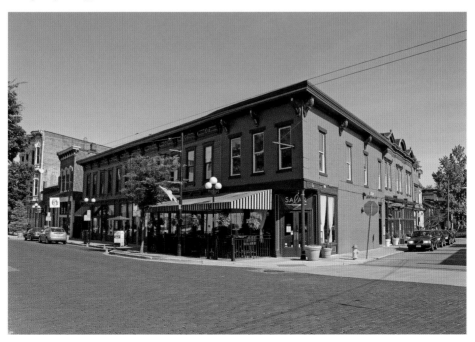

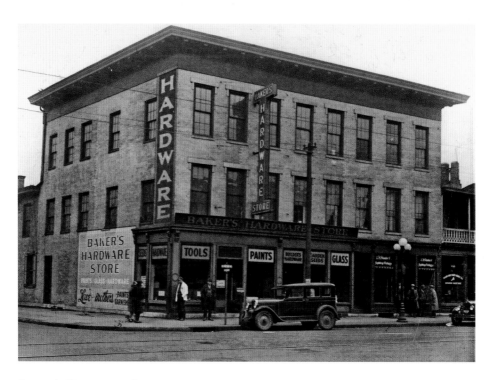

BAKER'S HARDWARE STORE: Built in 1851, this is believed to be the oldest surviving storefront in Dayton. In 1858, Albert C. Marshall began a hardware store at the southwest corner of Fifth and Jackson Streets. John F. Baker came on as a partner in 1875, later buying out Marshall in 1884. Baker's Hardware Store remained there until the 1960s. Part of the building was razed in the mid-1980s, but the rest was able to be saved. Since 2012, it has been the location of Brim, which sells hats and headgear.

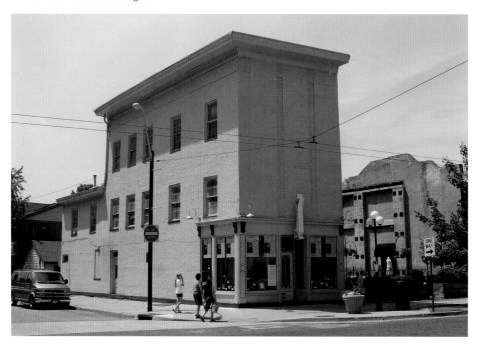

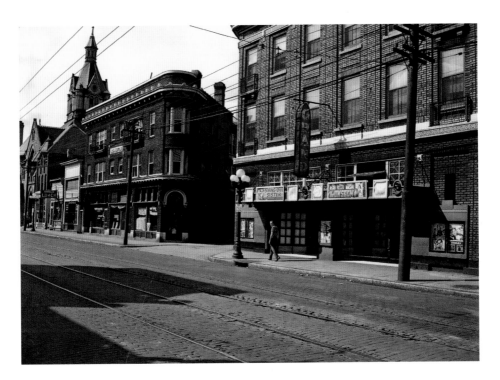

GRAND THEATER: Built in 1915, the 300-seat capacity theater was located at 601 East Fifth Street. The success the Grand had up until it closed in 1958, stems from the fact that the theater offered good movies, with a combination of first and second run films that ran from comedies and adventures, to westerns and the inevitable patriotic films during World War II. In 2014, it is the location of Ohio Budokan Martial Arts & Japanese Culture Center, which was founded in 1983.

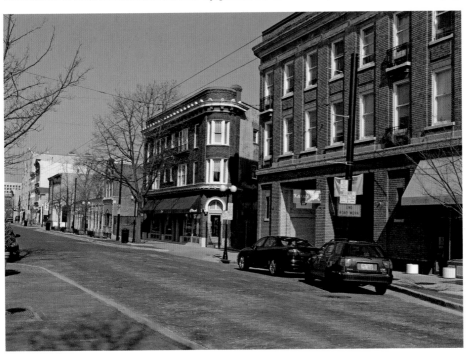

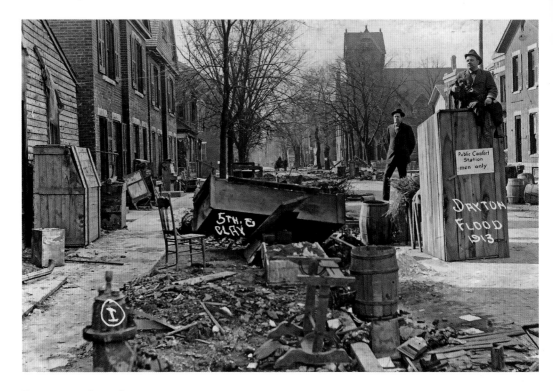

FIFTH AND CLAY STREETS: Debris clutters the streets, the aftermath of a flood that swept through Dayton in March 1913. One of the men sits on a "comfort station," which was used until repairs to the sewers could be completed. With the exception of the wooden structure on the front left, this residential area in the Oregon District remains nearly unchanged 100 years later.

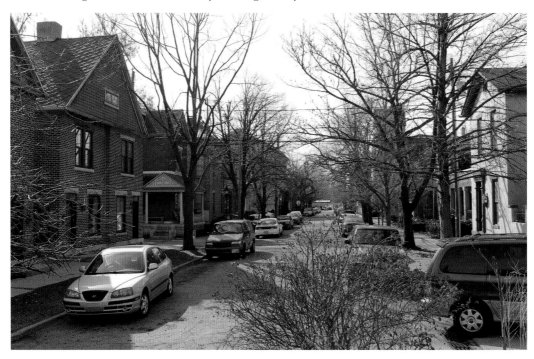

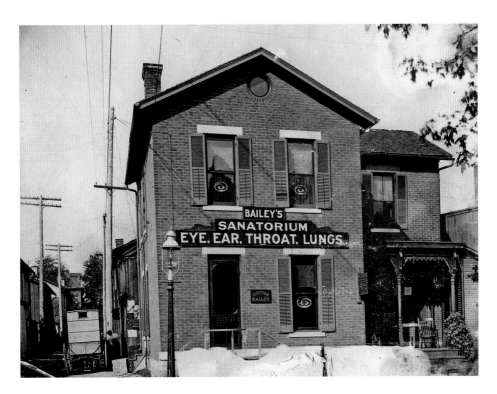

TUBERCULOSIS SANATORIUM: Originally a residence, by 1907 this house at 9 Clay Street had become "Bailey's Eye, Ear, Throat and Lung Sanitarium." Doctors K. M. Bailey, Sr. and Jesse K. Bailey, Jr. specialized in eye examinations and treating consumption. They also offered several patent medicines, including "Anti-Tubercular Serum," which they claimed would help a patient begin recovery immediately. In 2014, The Trolley Stop tavern uses the building for private events.

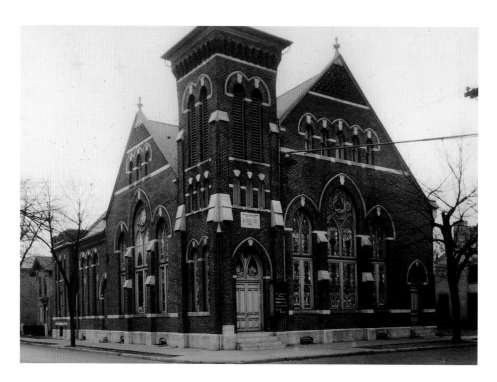

SECOND REFORMED CHURCH: This church grew out of a separation of a part of the members of the First Reformed Church, when in 1852 thirty families withdrew in order to have services in their native German language. In 1898, the congregation built this place of worship on the northwest corner of Clay and Cass Streets. Since 1996, the building has been occupied by the Urban Krag Climbing Center. Urban Krag features 8,000 square feet of textured and sculpted vertical terrain, with heights ranging from twenty-eight to fifty-six feet.

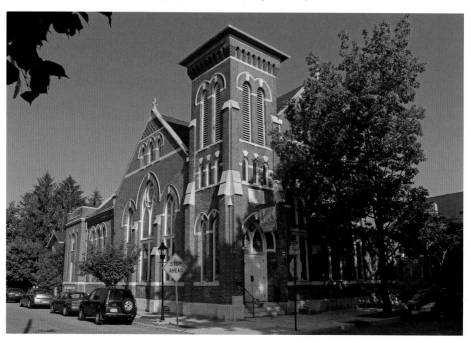

ICENBARGER'S OLD-FASHION DRUG
STORE: This Italianate-style brick
commercial structure at 200 Brown
Street was built about 1855. A number
of small bakeries, grocery stores and
drug stores leased the building over
the years. Frank T. Icenbarger began
his drug store there in 1889. He is
shown here in 1944, a year before he
would retire from the trade at the age
of eighty-two. Besides being a druggist
and an outlet for customers to have
their clothes dry cleaned by Troy-Pearl
Laundry, he also manufactured Puritan
Easter Dyes, for dyeing eggs. In 2014,
building is the office of architect Greg L.
Lauterbach.

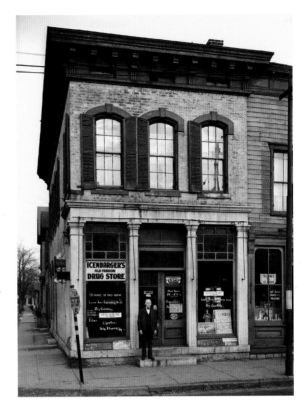

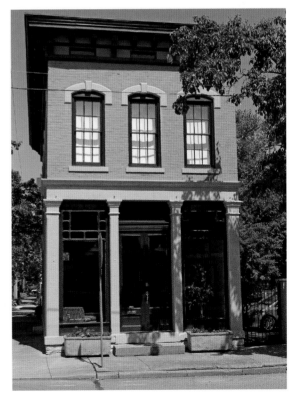

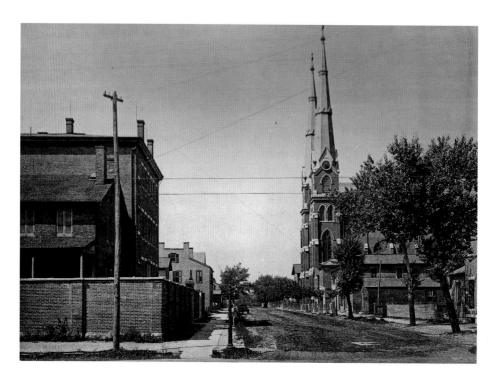

FRANKLIN STREET: This view is from Main Street looking west. On the southwest corner is the Notre Dame Academy, which opened in 1886 and was razed in 1957. The church on the left is Emmanuel Catholic Church. It was the largest church building in Dayton at the time it was completed in 1873. Emmanuel still holds services, although its two towers, which originally stood 212 feet high, have been considerably shortened.

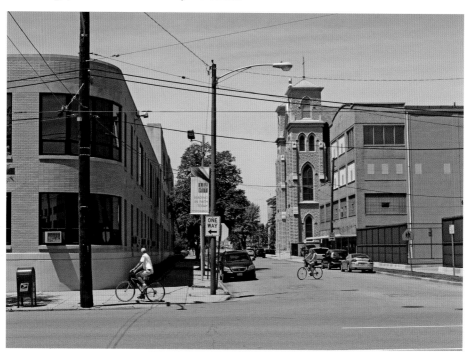

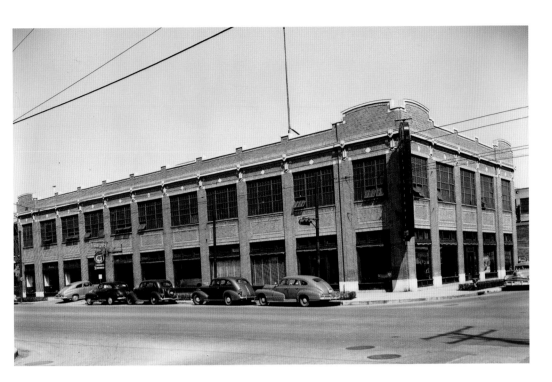

PACKARD DEALERSHIP BUILDING: The Citizens Motorcar Company began selling Packard automobiles in Dayton in 1908. Business grew to the point that in 1917, the company built a new showroom on the northeast corner of Franklin Street and Ludlow Avenue. The structure would eventually house several automobile dealers, including Rodgers' Pontiac, who moved there in 1946. Since 1992, it has been home to America's Packard Museum. It is the world's only restored Packard Dealership operating as a museum, and only full-time museum dedicated exclusively to the Packard Motor Car.

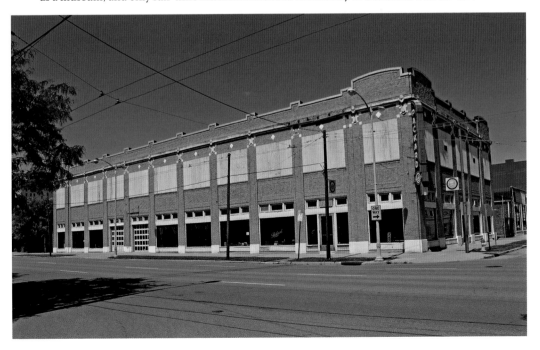

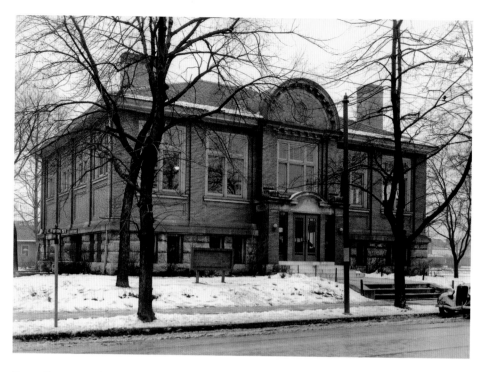

EAST CARNEGIE LIBRARY: Located at 2160 East Fifth Street, this was one of two library branches built with money provided by Andrew Carnegie, who gave away sixty million dollars to fund a system of 1,679 public libraries across the country. It was in service from 1914 to the fall of 1969. In 2014, the building contains offices for the Southeast Priority Board, a neighborhood council that allows citizen involvement in city government. The structure received an Ohio Historic Preservation Merit Award in 2008.

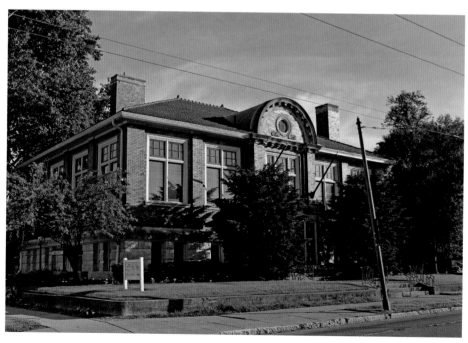

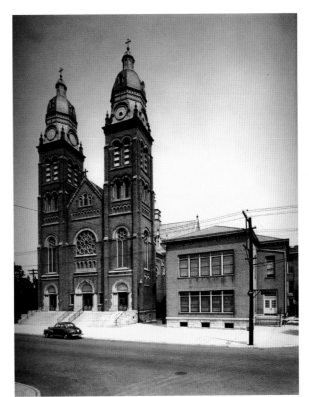

ST. MARY'S CATHOLIC CHURCH:
St. Mary's Parish was formed in 1859
when German-speaking Catholics
withdrew from the overcrowded
Emmanuel Catholic Church on
Franklin Street. In 1860, a church was
built at the corner of Xenia Avenue
and Allen Street. Overcrowding led to
a new church being built on the site in
1906 and a magnificent stained glass
window illustrating the life of Mary
was installed. World War II pilots used
the easily seen twin towers as a guide
for landing at Wright Field. St. Mary's
still serves as a place of worship.

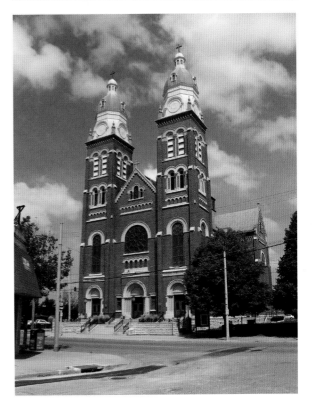

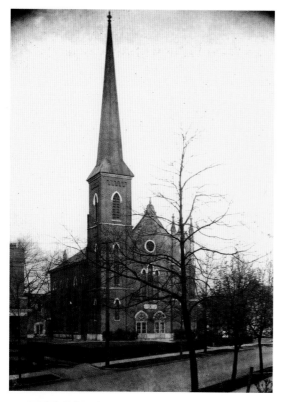

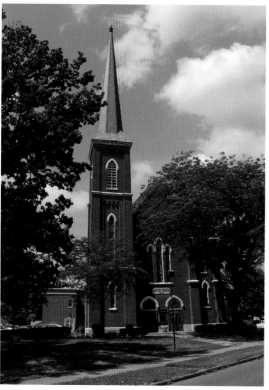

LINDEN AVENUE BAPTIST CHURCH:
This church was originally formed in
1872 by fifty-seven families from the
First Regular Baptist Church, the Wayne
Street Baptist Church and several others.
Construction of the church at 101 Linden
Avenue began in 1873, and the members
began worshipping in the basement
of the unfinished building in January
1874. The main auditorium was finally
completed in 1879. The church continues
to be a place of ministry and service to the
surrounding community.

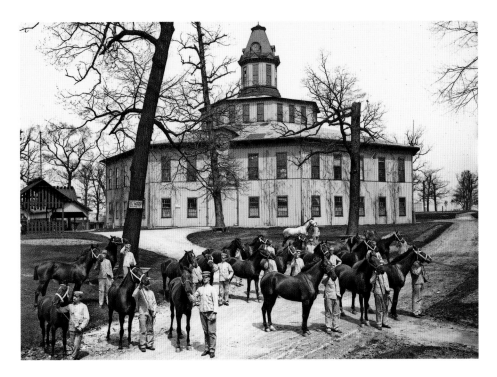

ROUND HOUSE: In 1856, the first fair was held on the present Montgomery County Fair Grounds on South Main Street. In 1874, the Southern Ohio Fair Association leased the land and built several buildings, including an eight-sided Victorian Italianate exhibition hall, which is now known as the Round House. As of 2014, the Montgomery County Agricultural Society, who owns the land, hopes to sell it and move the fairgrounds to Brookville, Ohio. The Round House is slated to make the move there as well.

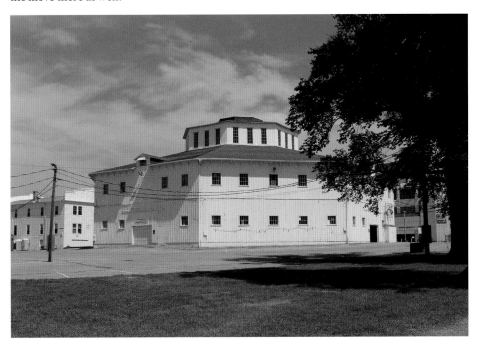

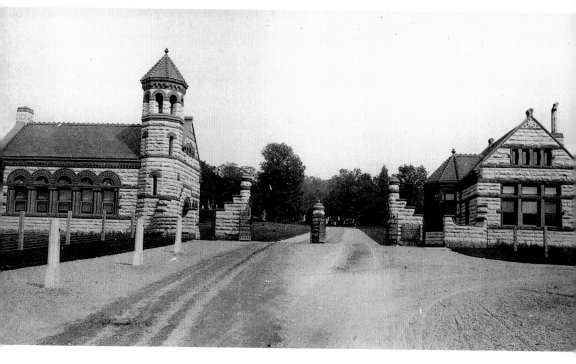

WOODLAND CEMETERY GATES: Built at the highest point in the city, the cemetery's first burial occurred on July 11, 1843. The Romanesque gateway, chapel and office were completed in 1889. Light enters the chapel through an original Tiffany window. The cemetery has become the final resting place for some of the nation's best-known individuals, including Orville and Wilbur Wright, Paul Laurence Dunbar, John H. Patterson and Charles F. Kettering.

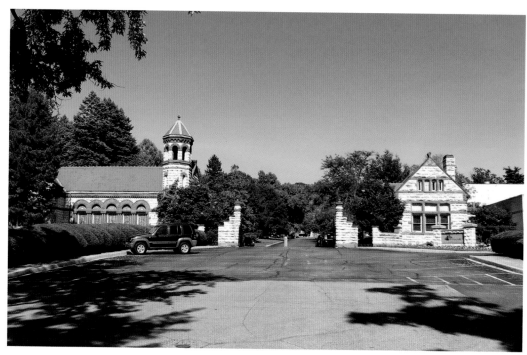

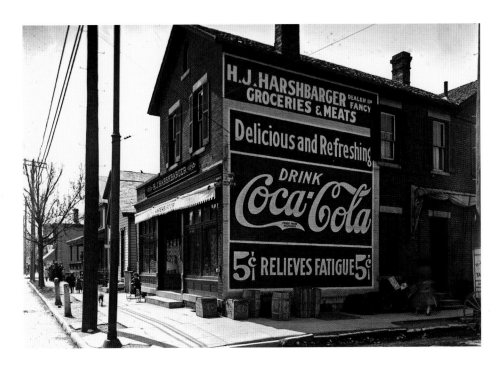

HARSHBARGER'S: Harry Jonas Harshbarger opened his grocery store on the southwest corner Brown and Ashley Streets in 1905. Harshbarger's was known for specializing in selling both dressed and live poultry. Customers could pick out a live chicken and have it prepared by the butcher in front of them, which ensured that the poultry was fresh; important at a time when there was no refrigeration available outside of an icebox. Unfortunately, the Great Depression hurt his business and Harshbarger had to close in 1930. In 2014, the Bourbon Street Grill & Cafe opened at this location.

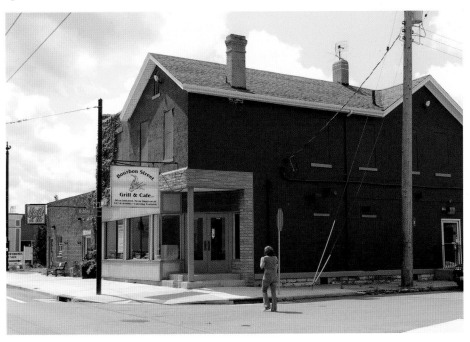

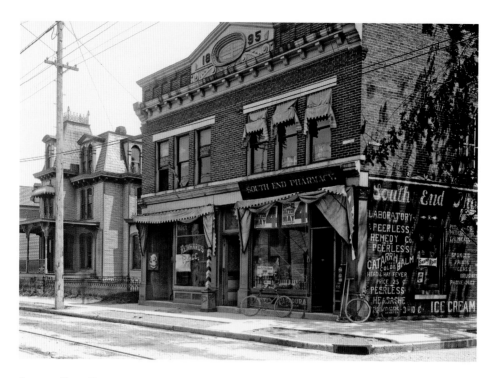

SOUTH END PHARMACY: After the pharmacy opened in 1895, it was soon joined by Harry Oswald's saloon, which took over the left-hand side of the building. The pharmacy proudly advertised that it manufactured products for the Peerless Remedy Company, who were known for their headache powders and catarrh balms. J. Elton Slade would eventually work his way up from drug clerk to owner of the pharmacy in 1915. In 1962, the now famous Old Hickory Bar-B-Q restaurant opened and has been serving great food there ever since.

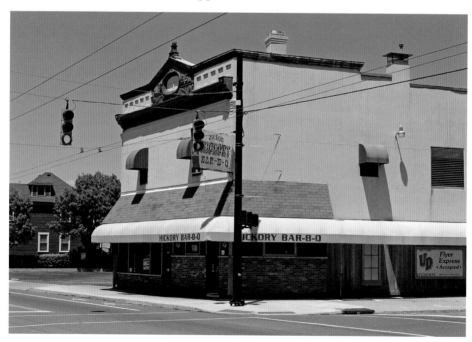

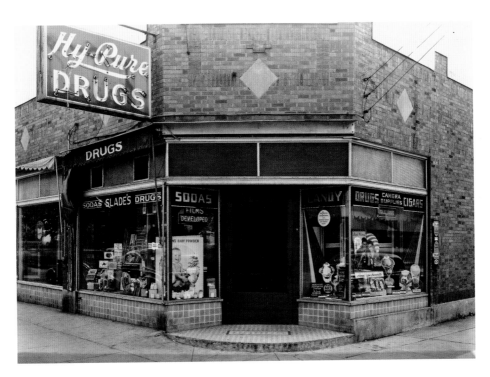

SLADE'S SOUTH END PHARMACY: In 1929, J. Elton Slade decided to expand and erected a new building for his pharmacy on the southwest corner of Brown Street and Fairground Avenue. In 2014, it is the home of Second Time Around. In business since 1976, the store sells used video games DVDs and blu-rays and is especially popular with the college students who attend classes at the nearby University of Dayton.

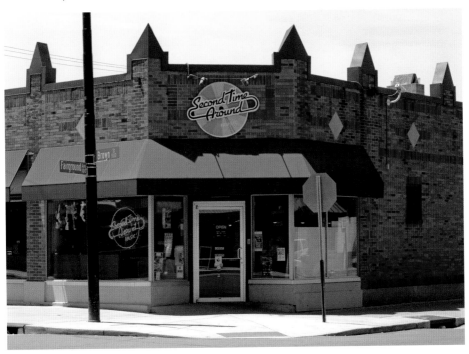

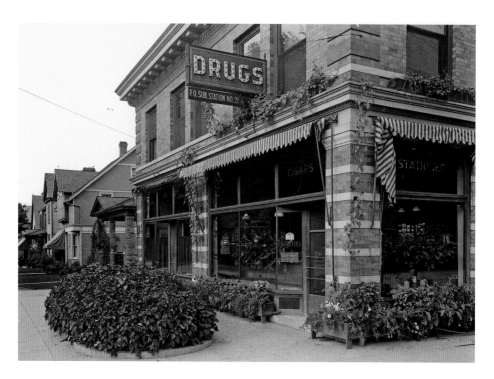

KID TULLIS SALOON: In 1908, Learmont "Kid" Tullis moved his saloon from across the street to its new location on the northeast corner of Brown Street and Irving Avenue. James W. Smyers was working as a drug clerk in Hamilton, Ohio, when he decided to go into business for himself. Tullis split the first floor of the building and Smyers opened the Rubicon Pharmacy on the right-hand side in 1912. In 2014, the building is home to the Studio Blue Color Salon and a Ben & Jerry's ice cream shop.

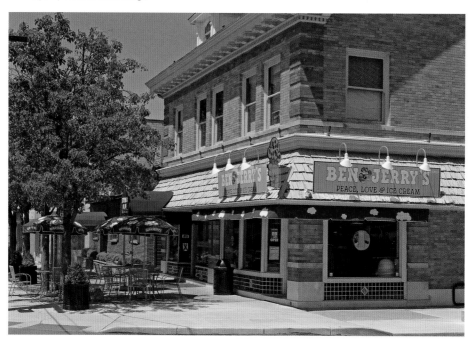

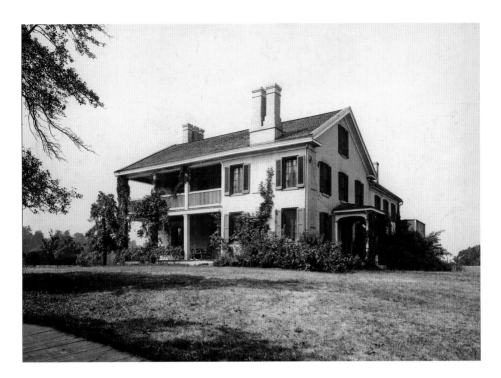

PATTERSON HOMESTEAD: This historic house museum provides a glimpse into the multi-generational lives of Dayton's influential Patterson family, who lived on the site from 1804 to 1904. The Federal-style house, which was constructed in three major components between 1810 and 1850, was originally the home of Revolutionary War veteran Colonel Robert Patterson, who helped found Lexington, Kentucky before moving to Dayton.

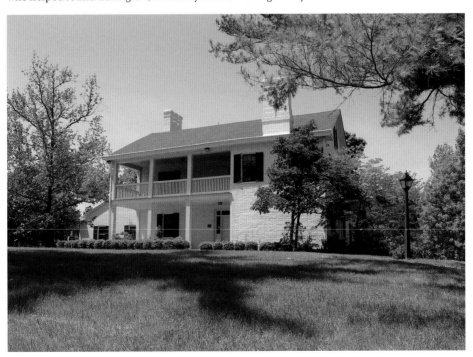

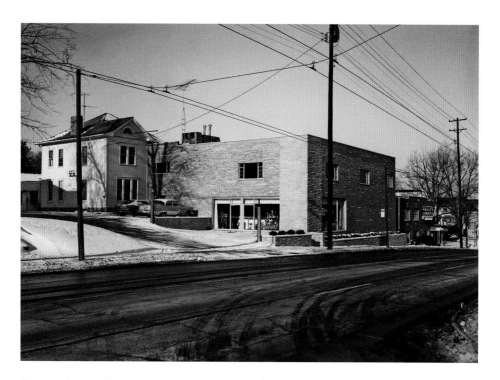

ESTHER PRICE CANDIES: In 1926, Esther Price began selling her homemade chocolate candy to her co-workers at Rike's Department Store. During the Great Depression she continued making chocolates in the basement of her home to help make ends meet. In 1952, Esther opened her first store at 1709 Wayne Avenue, which is still the company's headquarters. In 2014, Esther Price Candies has several retail stores in the Dayton and Cincinnati area and employs over a hundred people.

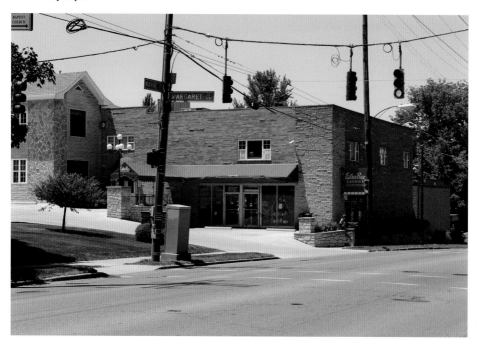

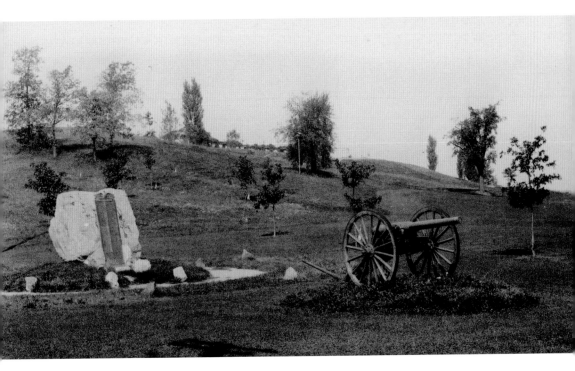

VICTORY OAK KNOLL MEMORIAL: Near the 18th hole of the Community Golf Course at 2917 Berkley Avenue stands a stone holding a bronze memorial inscribed with 180 names of Montgomery County men and women who had died in France during WWI. Dedicated in 1921, a grove of trees was planted around the memorial. At the base of each tree was placed a bronze disk engraved with the name, rank and organization of a fallen veteran. It was paid for by the Dayton Home Guard, who had been collecting money to buy uniforms. When the war ended it was decided to use the money for a memorial.

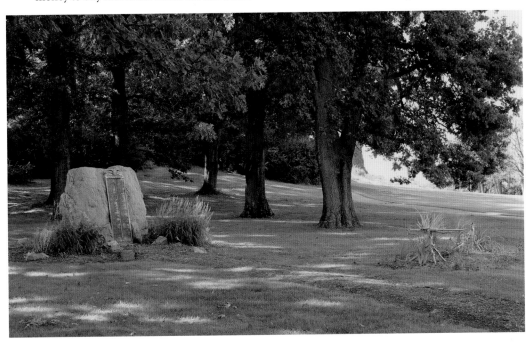

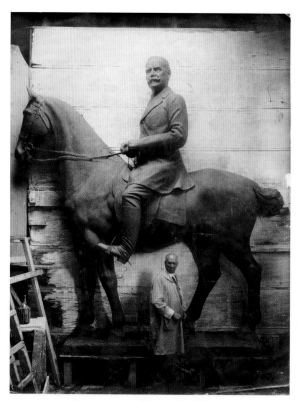

PATTERSON MONUMENT: Hills & Dales MetroPark, located on South Patterson Blvd., was originally for use by National Cash Register company employees. John H. Patterson donated the 294-acre park to the city in 1918. After Patterson died, a monument was erected overlooking the park. Dedicated on May 26, 1928, the thirteen-foot high bronze sculpture by Giuseppe Moretti shows Patterson astride his favorite saddle horse, Spinner. The figures on each side of the monument represent education, industry, progress and prosperity. (Top image from Birmingham, Ala. Public Library Archives)

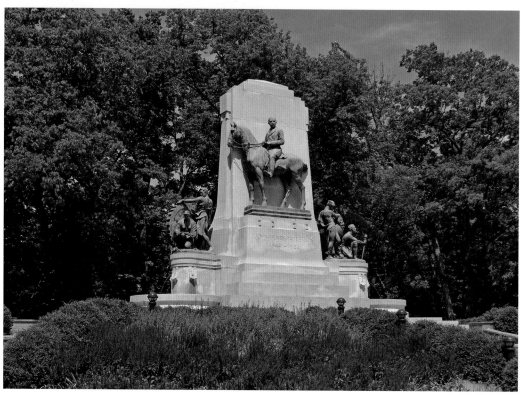

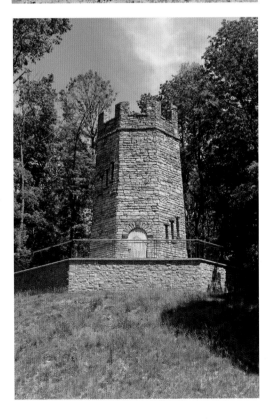

LOOKOUT TOWER: Also located at Hills & Dales MetroPark, south of the Patterson monument, the tower was built by young men who were given jobs during the Great Depression by the National Youth Administration. Finished in 1941, it required a year to build and was constructed of stone salvaged by the city from condemned buildings. The top of the tower is now gone and the front door and side window openings have been sealed to prevent entry.

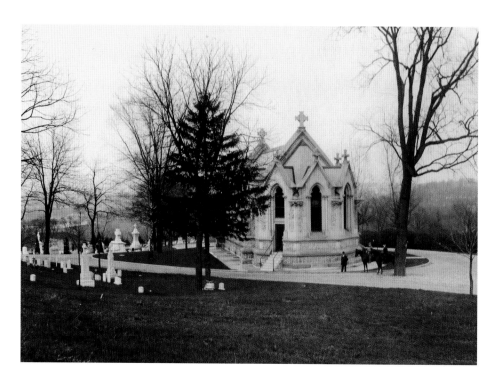

ST. HENRY' CHAPEL: St. Henry's Cemetery was located on South Main Street, across from the Fairgrounds. In 1889, plans were made to move the graves to Calvary Cemetery, at 1625 Calvary Avenue. During this process, some of the graves could no longer be identified from their markers. A stone chapel was erected at Calvary as a place of re-interment for the unclaimed deceased. St. Henry's Chapel was dedicated on All Souls Day, 1902.

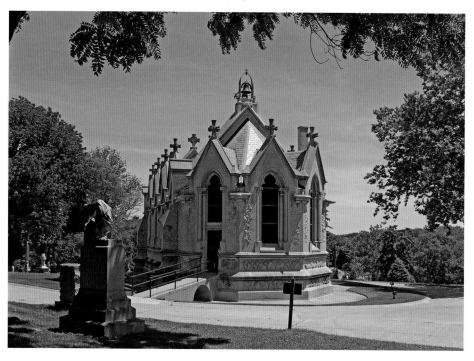

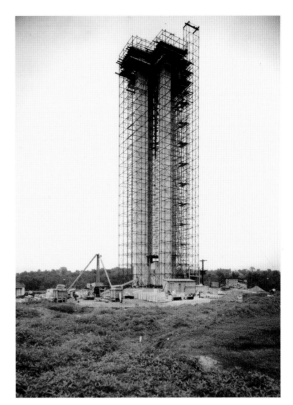

DEEDS CARILLON: Built in 1942, this carillon was funded by Edith Walton Deeds as a tribute to both her husband, Col. Edward A. Deeds, and her family. The tower originally had thirty-two bells. Of these, twenty-three were electrically rung, each inscribed with the name of a living family member. The other bells were silent and carried the names of deceased family members. The fifty-seven bell carillon has since been modernized to play up to 10,000 tunes remotely or a carillonneur can operate the bells via a mechanical keyboard.

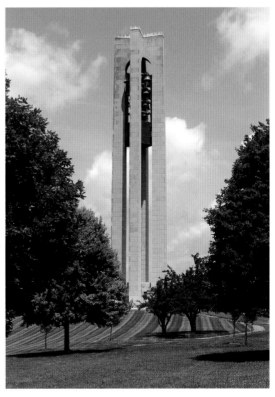

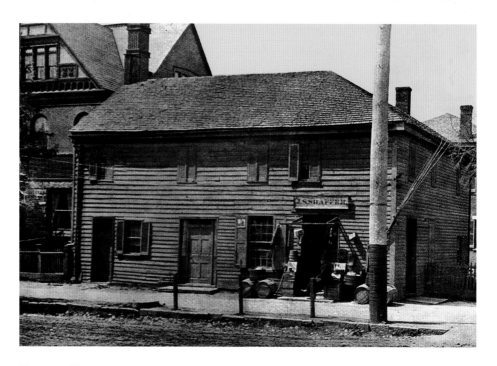

NEWCOM TAVERN: Dayton's oldest standing structure was completed in 1798-99 for Col. George Newcom. Originally located at the southwest corner of Main Street and what is Monument Avenue in 2014, the hewn-log structure served as a residence, courthouse and store. Clapboard siding was later placed on the log building to formalize it. Joseph Shaffer kept a grocery store there from 1838 to 1894. The building was moved to Van Cleve Park on Monument Avenue in 1896, during the city's Centennial celebration. The clapboard siding was removed to show just how far Dayton had progressed in a hundred years.

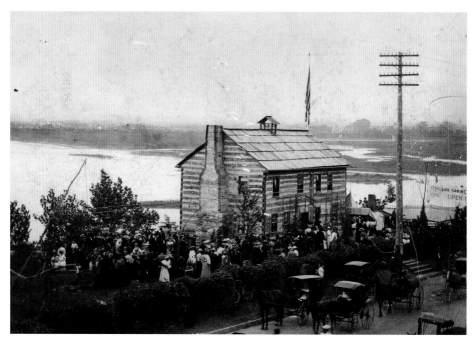

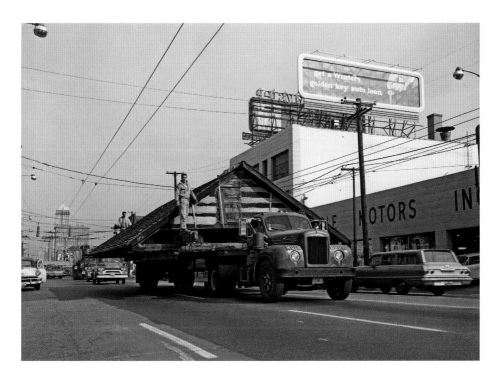

NEWCOM'S MOVED ONCE AGAIN: In 1964, the tavern was moved to its present location at Carillon Historical Park. In 2014, the building underwent a $100,000 exterior renovation. The logs were treated with a wood preservative and insect repellent. Oak lath was then applied, to which sash sawn white oak weatherboard was attached, and a new chimney face was built. The restoration was carefully planned so that it can be reversed without damage to the tavern if required in the future.

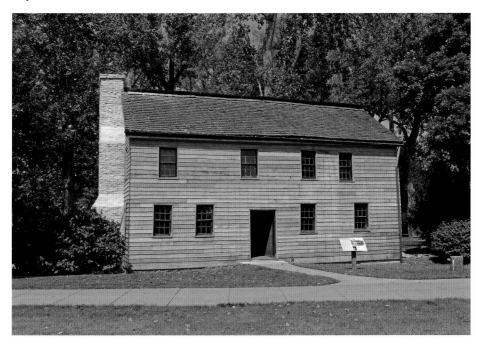

ACKNOWLEDGMENTS

As with any book of this nature, it could not have been written without the help of others. I wish I could have met the writers of earlier times who helped preserve the history of Dayton for future generations. Men and women like Charlotte Reeve Conover, Frank Conover, Harvey W. Crew, Rev. Augustus W. Drury, John D. Edgar, Mary Davis Steele and Robert W. Steele, to name but a few. They have inspired a number of others to continue that legacy, including me.

I also wish I could have met the photographers of that time who helped preserve the history of the city. Among them are A. Lincoln Bowersox, Thomas W. Cridland, John Dolley, Estella Kile and Milton Wolfe. Unfortunately, although many of their names are known, most of their work goes uncredited. However, the images that remain bring to life the people, places, and events that define our community today.

But since I cannot travel back in time, I will do what I can and thank them here instead.

And I want to extend my thanks to Robert A. Makley. Although I took most of the present day photographs for this book, I could not pass up Robert's offer to include some of his unique images. His wonderful photographs can be found on pages 11, 27, 44 through 49, 51 and 53. I admit I am quite jealous of his talent behind a camera.

Most of the older images come from the vast collection owned by the Dayton Metro Library. Those that do not are credited below. My thanks to everyone for their help in searching for just the right images to tell the story of Dayton through time.

Birmingham, Ala. Public Library Archives: page 90

Dayton VA Medical Center: pages 47, 48, 51, 52, 53

From the collections at Dayton History: pages 8, 13, 16, 30, 32, 71, 73, 79, 85, 88, 91, 93

From the NCR Archive at Dayton History: pages 11, 39, 56, 58, 59, 64, 67, 75, 77, 81, 83, 84, 86, 92, 95

From the William Preston Mayfield/Marvin Christian collection at Dayton History: pages 55, 57

Library of Congress: pages 20, 22, 26, 45

Harry Seifert: page 46, 49